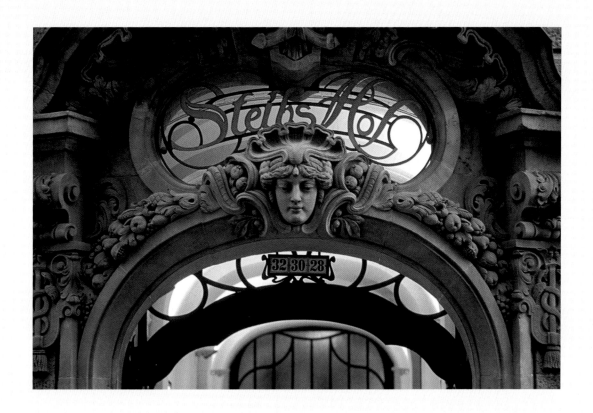

Journey through

LEIPZIG

Photos by
Tina and Horst Herzig

Text by
Bernd Weinkauf

Stürtz

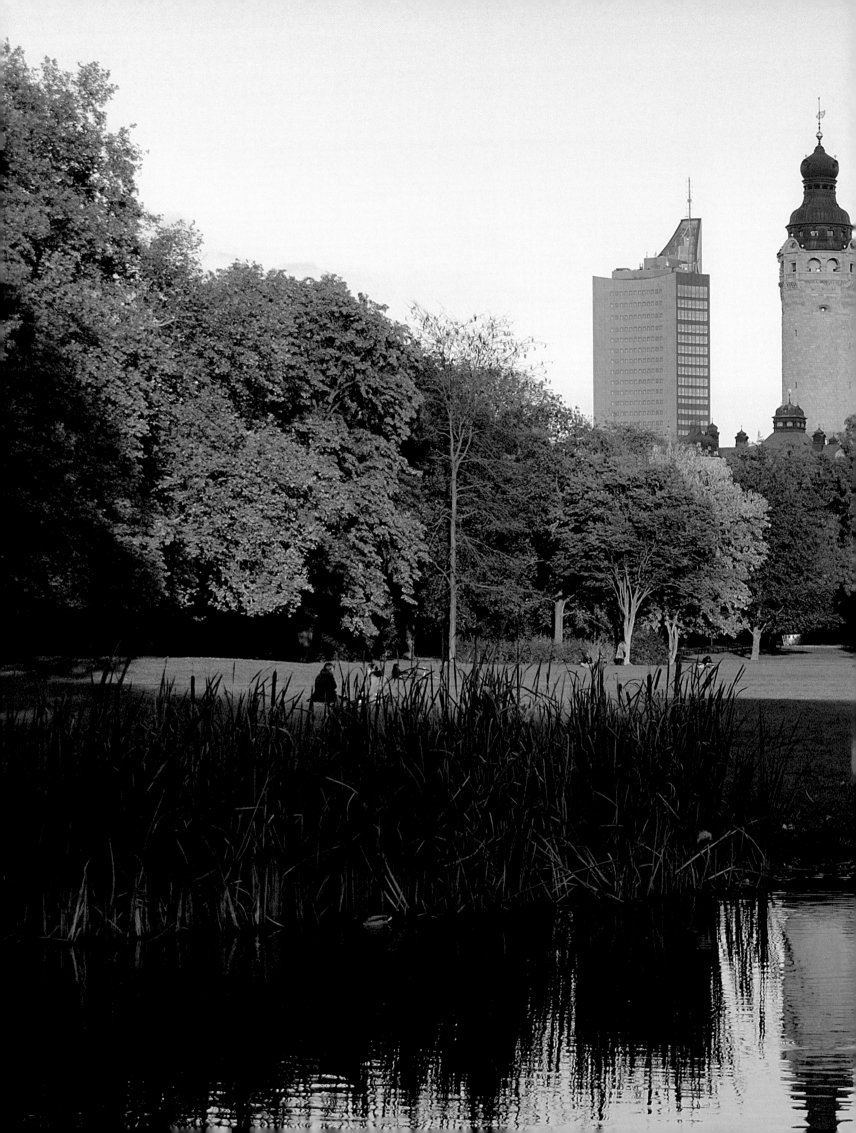

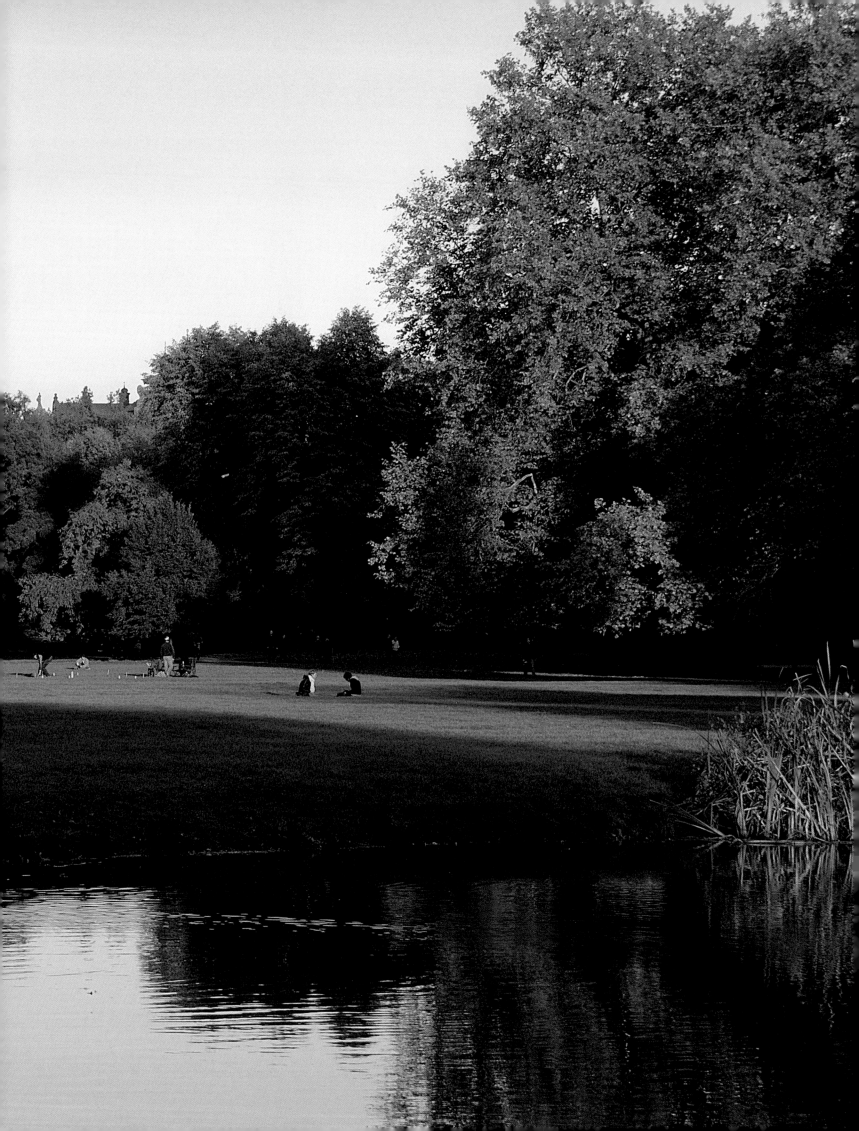

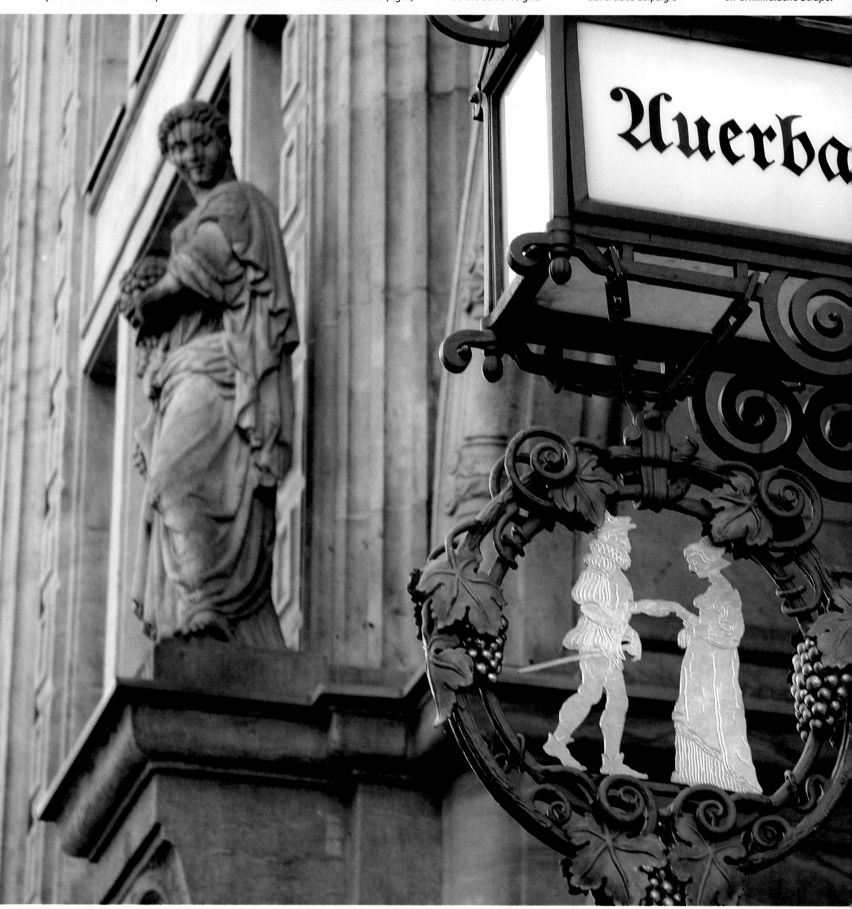

First page:
From the doorway of the Historicist trade fair and fur merchant's Steibs Hof

built in 1907 Lipsia, the assumed patron of the city, gazes out towards the Nikolaikirche.

Previous page:
Seen from the Johanna-park close to the centre of town the tower of the Neues Rathaus (right,

114 m/374 ft) and that of the City-Hochhaus (142 m/466 ft) seem to be the same height.

Below:
High up above the heads of the punters an old-fashioned pub sign advertises Leipzig's

very own underground sensation, the world-famous Auerbachs Keller on Grimmaische Straße.

8

Page 10/11:
Johann Sebastian Bach
positively dominates
the square outside
St Thomas's; here the

great composer has his
own church, museum,
archives, pub, souvenir
shop – and obligatory
boxes of chocolates.

Contents

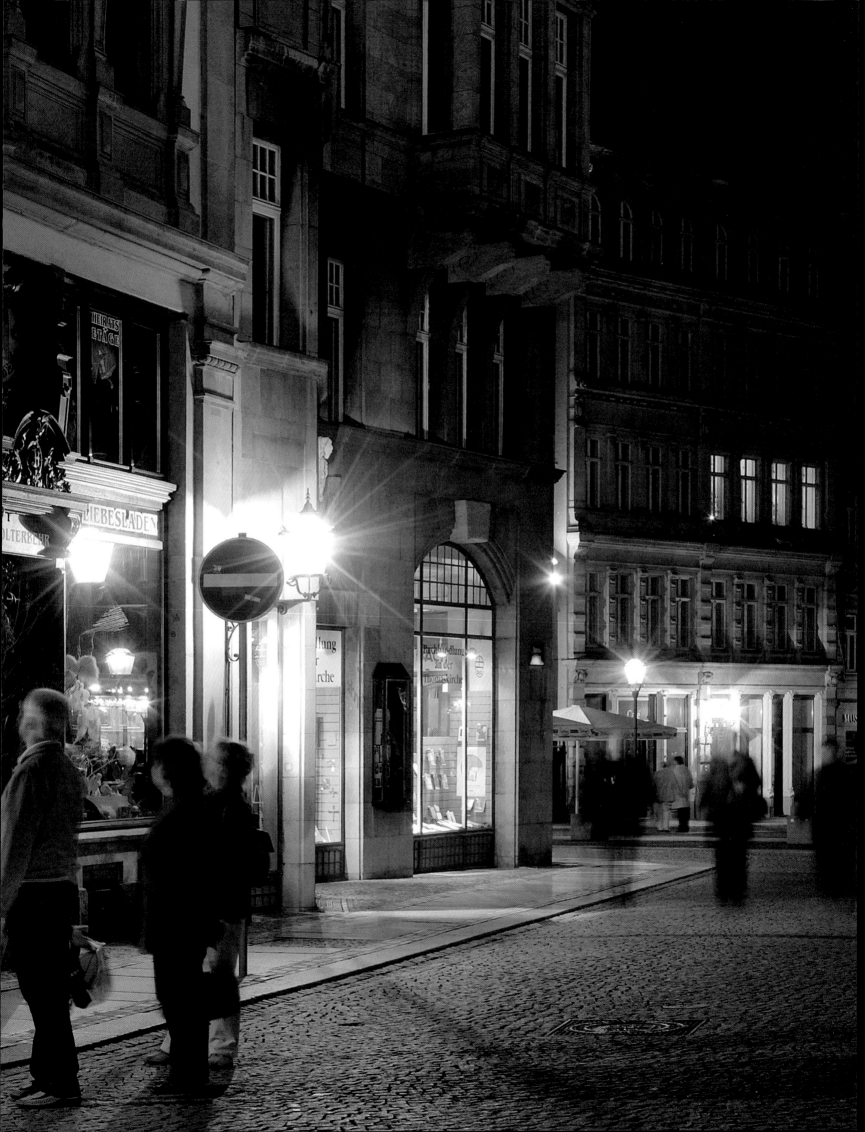

In the middle of Europe: Leipzig

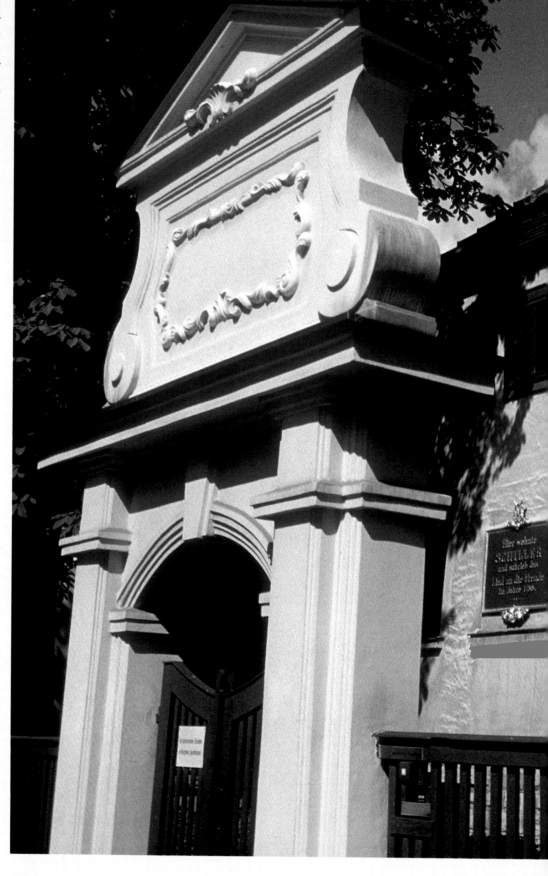

The middle of Europe? Geographically speaking, not exactly – although it seems like it. The city of Leipzig is equidistant from both Madrid and Moscow, from both the Bosporus and the Faroes (ca. 1,500 kilometres/930 miles from each). There were and still are many reasons for travelling to Leipzig. And many different routes. In emulation of the famous saying that all roads lead to Rome – which lends itself to spiritual rather than logistical interpretation – without shameless exaggeration we could say that all (Central European) roads lead through Leipzig. This low rocky spur in the midst of a swampy riverine landscape proved desirable to settlers very early on in our history. A saga going back to Leipzig's year dot documents – albeit only verbally – the lives of these ancient pioneers. With food and fuel aplenty in the direct vicinity Slavic tribes came and set up home. Unfortunately they also found a ferocious dragon on their doorstep whose ravenous appetite could only be sated by human sacrifice. A suitable princess was promptly found with the wonderful name of Ankomarinde. And where there's a dragon, there's a knight called George. Whilst on his infamous dragon-slaying tour of Europe he happened to pass by and dispatch the beast, claiming as his modest reward only that the grateful *Leipziger* recover his trusty stead's lost horseshoe. Humbled and relieved they duly did so, hanging it on a linden tree in honour of the gentlemanly cavalier. In the local vernacular the lime was known as a *lipa*; over time this mutated into the word Leipzig. When amidst the missionary zeal of Christian monks the 'heathen' linden was felled the relic of the now saintly young George

was reverently given pride of place in their new place of worship. The proof of the pudding lies in the fact that the horseshoe, Leipzig's oldest symbolic artefact, is still safeguarded in the Nikolaikirche.

The fact that St George chanced upon Leipzig is no coincidence. Even in the days of dungeons and dragons (the 'genuine' article, not the 1970s game) the area was well situated and heavily frequented. The oldest thoroughfares which, like the ancient Silk Route, crossed entire continents and joined the Orient with Scandinavia and the Atlantic with the Volga all intersected here. The ensuing Roman roads, such as the Via Regia (the imperial route from east to west) and the Via Imperii (the route of kings from north to south), are still relevant to our recent history if you consider that Germany's first motorway junction, the clover leaf of the Schkeuditzer Kleeblatt, was built fanning out in the same directions in 1936. Leipzig's older, positively enormous main station is also rooted in this ancient tradition. In keeping with American models and keen on exploiting its central location economist Friedrich List propagated the turning of Leipzig into the "ventricle of the German railway". In the space of just a few years Leipzig had not one but three stations serving the four points of the compass. The transfer from one to the other soon proved irksome, however, and in 1915 the railway companies of Saxony and Prussia joined forces to open the "largest terminus station in Europe", as Leipzig is still proud to call it. Its giant dimensions are the result of it being two stations rolled into one. (Incidentally, as any railway buff will tell you the largest terminus station in the world is in St Louis, Missouri, built for the World's Fair or Louisiana Purchase Exposition in 1904).

Trade and exhibitions

The main purpose of the first long-distance German railway opened in 1839 between Leipzig and Dresden was to transport merchandise. Since its beginnings Leipzig has been a centre of trade for all kinds of goods, the pinnacle of its career as such marked by the elevation of its annual market to imperial fair in 1497, its machinations now under the protection of the emperor of Germany. When Leipzig's German castle was first mentioned in writing in 1015, as in many other strongholds dotted about the country markets had long been held within its mighty defences. Sufficient sanctuary from the Grim Reaper was not granted a certain Bishop Eid of Meißen, however, in conjunction with whom this first

13

record was made. He had the misfortune to die on his way to Merseburg "in urbe libzi vocata" (in the place known as Libzi or Leipzig), as a medieval chronicler remarked.

In the second half of the 13th century Leipzig was inundated with merchants from all over Germany (but mainly Nuremberg) who soon became Leipzig's chief businessmen. These travelling salesmen, who called themselves *Fieranti* or men of the fair, were largely responsible for establishing Leipzig's lucrative position as a place of trade. A letter issued by Margrave Dietrich von Landsberg in the year 1268 guaranteed foreign merchants and their cargo travelling to the fair in Leipzig safe conduct – even if they happened to find themselves at odds with the local lords. Landsberg arrows on a gold background, the heraldic symbol of the then ruler, are still sported by the city's coat of arms, together with the lion of the royal house of Wettin. Leipzig's status of imperial trade fair was permanently sealed in 1507 when Emperor Maximilian attested its right to store and trade in goods. His decree guaranteed that no other depots or warehouses could be set up within a radius of ca. 115 kilometres (70 miles). In addition, all goods which were transported within or through the designated area had to be brought to Leipzig along prescribed routes, weighed, declared for duty and offered for sale for a period of three days. The profit local tradesmen made on this option of purchase and intermediate trade laid the foundations for the city's rise to fame and prosperity in the 16th century. This boom in trade enticed merchants from England, France, Italy and Flanders to Leipzig, many of whom settled permanently. Between 1523 and 1592 18 merchandising houses were built, "half-cities" which 200 years later impressed Johann Wolfgang von Goethe so much as to prompt him to declare: "Entirely to my taste were, however, the buildings which I found tremendous and which, their visages fronting two streets, a bourgeois world enclosed by huge courtyards built up to the skies, are like large castles, even half-cities." In view of this development we can also understand why historian Christian August Clodois wrote what he did in 1779: "Leipzig, the city where so many efficacious strangers came with their staff in their hands, and with

their talent, diligence and the grace of God procured tons of gold." One of these visitors who was less fortuitous in the accumulation of wealth in Leipzig was Gotthold Ephraim Lessing. Yet even he treasured Leipzig in the 1740s for the fact that here you could see "the entire world in miniature". Even in the early 20th century life in Leipzig was still profiting from the city's various exhibitions. The observant chronicler Victor Klemperer experienced it thus in 1917: "The flood tide of the exhibition has drained away yet still there is no ebb tide in sight. Leipzig does not know what an ebb is."

Auerbachs Keller

Trade was not only instrumental in the transportation of goods; it also helped disseminate novel discoveries and new ideas. On their return home merchants commented on the quality of life in the rich trade centres of Europe – particularly Leipzig. When squabbling between the nations put a stop to regular instruction at the University of Prague in the spring of 1409, around three hundred students, doctors and professors abandoned the Bohemian capital to found a new seat of learning. They plumped for Leipzig, choosing it for its central location and good reputation. One of the oldest universities in Germany was thus founded and soon became one of the country's leading educational establishments. One of the greatest names to grace its first century of operation was medic Heinrich Stromer von Auerbach whose occupational sideline, a wine tavern known as Auerbachs Keller and a hot favourite amongst the students and businessmen of its day, remains more firmly fixed in our minds than his academic prowess. It was Auerbach who founded the anatomy department in Leipzig, who researched the bubonic plague and who, as vice chancellor, has passed on to us the subjects the medics of the time studied for their PhDs. He was also an active follower of the Reformers Martin Luther and Philipp Melanchthon and probably knew the infamous D Johann Faust personally. At Whitsun in 1539 Luther preached the new faith in Leipzig and in 1545 in the wake of the Reformation he consecrated the dissolved Dominican monastery of St Pauli as the new university chapel. The fact that this old and historically significant building was dynamited in 1968 for aesthetic reasons has left such deep wounds in the hearts of the people of Leipzig that these were again reopened when the debate was recently begun as to whether the church for the new university should be a reconstruction of the beloved St Pauli or be built to a completely different design.

This is the youngest of Leipzig's many arcades, running beneath the Zum Strohsack ("straw sack") building, erected in 1997. The name goes back to the 16th century when the site was occupied by a student hostel.

Great minds

It's impossible to describe in brief the great role the university of Leipzig has played in the dissemination of world knowledge. To keep it short just a handful of names shall be mentioned here, the selection of which makes no claims whatsoever to rank or order of importance. The development of the natural sciences shall be represented by the father of mineralogy Georg Agricola, universal genius Gottfried Wilhelm Leibniz and Danish astronomer Tycho Brahe. Two Nobel Prize winners can be quoted in conjunction with learning and research in our not-so-distant past: chemist Wilhelm Ostwald, whose examinations of the colour spectrum are still pertinent, and physicist Werner Heisenberg, who was partly responsible for the development of nuclear fission technology in Leipzig. The university is no less prolific when it comes to the arts. The most famous student of the law faculty is undoubtedly Goethe who in Leipzig honed his talents not only as a legal eagle but also as a poet – with his official course of study later earning him the post of minister in Weimar. It seems fitting that he should have become one of the academic pillars of the German Studies department at his alma mater; Georg Witkowski, Hermann Kroff and Hany Mayer are among those who have helped mould the machinations of Goethe research in Leipzig. It was here that jurist and historian Theodor Mommsen worked on his standard textbook of Roman history which was awarded the Nobel Prize for Literature in 1902. Germanist Theodor Frings penned his history of the German language here and students of various temperaments and persuasions have included Friedrich Nietzsche and Karl Liebknecht, Erich Kästner and Uwe Johnson.

One 18th-century encyclopaedia remarks that thanks to its flat countryside Leipzig and its environs were predestined for battles to be fought here. Looking through the chronicles there's plenty of proof to back this theory up. All of the major tussles enacted in Central Europe have left their bloody mark on Leipzig. The Moritzbastei, for example, still boasts a pyramid of stone shot from the Thirty Years' War. Near Breitenfeld and Lützen, not far from

town, monuments tell of the conflicts staged by king of Sweden Gustav Adolf II. Apart from an inordinate measure of chaos the Swedish occupiers did actually bequeath to Leipzig an invention which we are still profiting from today. In 1642 the Swedish war commandant commissioned printer of books Timotheus Ritzsch with the production of a daily news bulletin. After the troops had retreated Ritzsch continued to develop the idea and in 1650 published his "recently received news of war and trade", the first German newspaper which was issued under the name of *Die Leipziger Zeitung* until 1924.

The Battle of the Nations at Leipzig

The Seven Years' War, during the course of which Leipzig was occupied by Prussian soldiers for six years, six months and six days until 1763, brought with it the sobering revelation that town walls, moats and ditches were no longer pertinent to the protection of the city. In 1778 Mayor Carl Wilhelm Müller thus began tearing them down and having them turned into pleasant green open spaces, in one of which the thankful burghers of Leipzig later erected a monument in his honour.

One of the most brutal wartime events in Europe which is inextricably linked to Leipzig was the Battle of the Nations in October, 1813. As a result of the defeat of the French army and her allies, one of which was Saxony, the political progress which Republican France could have infused Germany with was seriously curbed. The royal thrones wobbled precariously yet remained steadfast – to the disappointment of those who had made many a sacrifice in the battle against foreign rule and for freedom in their own country. Following the war Saxony shrank by three fifths but remained a kingdom at the grace of Napoleon. It can be said without exaggeration that the memory of this now extremely distant event is still very much alive. The vast monument to the Battle of the Nations and the rather exotic Russian memorial church, both erected on the hundredth anniversary of the conflict, plus the Apel stones dotted about town which give details of the battle, plus many other marks of remembrance, just won't let us forget it. The city itself was less affected by the ravages of war than the villages round about which had to be rebuilt and were soon larger than they were before the hostilities. Leipzig itself also underwent a rapid development which sprawled out beyond the old city confines. Augustusplatz, for example, was one of the generous squares to be laid out, upon which many important buildings were

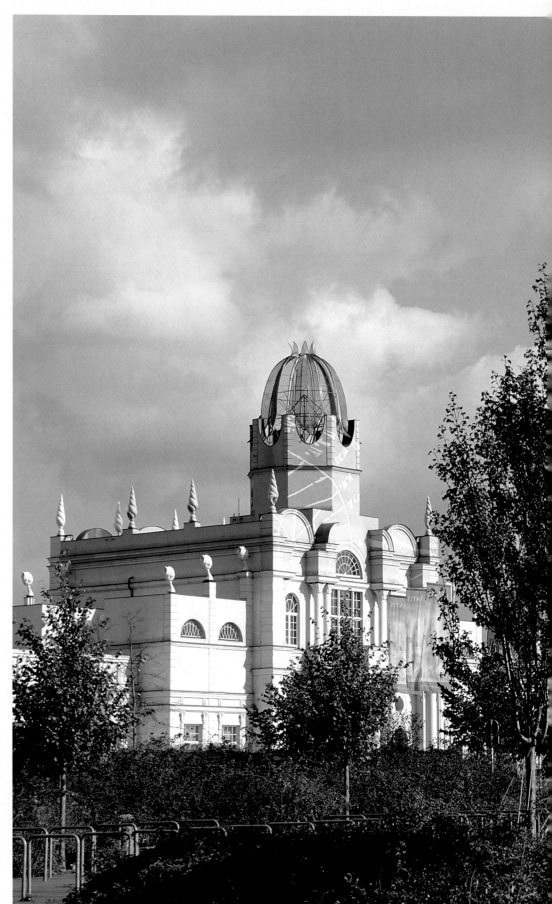

erected in the space of just two decades: the new university building, the main post office, the Neues Theater and the museum of pictures. On March 31, 1841, Theodor Fontane arrived in Leipzig to conclude his course of studies as a pharmacist. In his memoirs entitled *Von Zwanzig bis Dreißig* (From twenty to thirty) we can read: "I had undertaken two thirds of the journey by rail and the last third by mail coach. We now stopped outside the large post office building recently completed, the square with the university and Paulinum stretched out before us. It must have been six o'clock; the air was soft, the bushes in the parks were in green bud. The mood was faintly nebulous. I had a good stretch, took a deep breath and had the feeling of relative safety. And so it was. What is said about first impressions certainly has an element of truth about it. – The Neubertsches Haus was on Hainstraße, meaning that I would have to pass the most genuine and beautiful part of Leipzig, the Grimmasche Gasse and Rathausplatz, to get there. My porter trotted alongside me and gave me a tour in good Saxon. I was quite dazed and would go as far as to say that, considering architecture and townscapes alone, nothing in my life since has made such a great and, it is odd to say, intoxicating impression on me as this street from the post office and university square [= Augustusplatz] to Hainstraße, although it may be only of modest merit artistically. This may be explained by the fact that, apart from a number of hamlets in the Mark and Pomerania where I spent my childhood years, I had until this hour known nothing else of the world except good old Berlin which had always been described to me by all genuine Berliners as the epitome of urban beauty. And now! What a revelation!"

Leipzig is seldom praised in such glowing tones; what Goethe has the student rabble shout in *Faust* is pure sarcasm: "I praise my city of Leipzig! It is Paris in miniature and educates its citizens." Comparing anything to Paris at the time was an insult – yet the people of Leipzig still managed to turn this to their advantage.

Portrait of a city

Opinions on the beauty of Leipzig are still divided. When forming our own view we should bear in mind that Leipzig is not old on the surface. There are no city gates, no half-timbered houses, no romantic narrow streets. Down the centuries Leipzig has been moulded by the requirements of its trade fairs; a suitable backdrop had to be provided for somewhere where the latest fads from all corners of the globe were proudly presented. For this reason the ironic comment was once made that the exhibition centre of Leipzig is the only one in the world which has its very own town. This explains why in Leipzig many buildings of old have been thoughtlessly removed and new ones erected in their place. As late as at the beginning of the 20th century the old town hall from 1556 was miraculously only just saved from demolition by a majority of one at the conclusive meeting of the council.

In 1765, two years after the end of the Seven Years' War, Goethe found himself in a lustily baroque city which made the following impression on him: "When I arrived in Leipzig there was a fair on [...] This state of agitation was, however, soon over and now the city greeted me with its beautiful, high buildings equal amongst one another. It made a very good impression on me and it cannot be denied that it has something impressive about it, especially during the still moments of Sundays and feast days and when the streets are bathed in moonlight, half lit, half in shadow, enticing me to undertake a nocturnal promenade. – However, compared to what I was used to this new state of being did not fulfil me in the slightest. To its visitors Leipzig does not recall the days of old; it evokes a new, recently past epoch which smacks of trade, affluence and riches heralded to us by these monuments."

Leipzig recovered less rapidly from the bombing of the Second World War. The situation shortly after the war (1950) is described by journalist Dieter Zimmer in his family chronicle *Für'n Groschen Brause* (Sherbet for a penny): "Augustus-Karl-Marx-Platz was enormous and probably seemed more spacious than it used to be due to the gaps in the building. Towards the main station were the ruins of the opera house which were torn down during these weeks. A decision had not yet been reached as to whether the new Oper should be erected on the same site or opposite, where the remains of the picture gallery now stand. The best thing to do is just build, said Father, the square will be formed later." And so it was. Buildings were put up at random with no recourse to site bound-

Just twenty years ago this was a dirty gaping hole where brown coal was mined. It has since been transformed into the serene Cospudener See, complete with a harbour, pubs and cafés and a lakeside promenade, giving Leipzig a distinct maritime flair.

aries and given structures. Long after 1945 Leipzig still bore the ugly scars of World War II, with the damage steadily eating away at the fabric of the town. The ironic slogan coined by the people of Leipzig says it all: "Make ruins – without war". Towards the end of the 1980s the question as to whether Leipzig could still be saved was tantamount to a sigh of resignation. When in 1983 prayers for peace were first held in the Nikolaikirche, worshippers petitioned for an overall truce "in urbi et orbi" – in both the town of Leipzig and throughout the world in general. On October 9, 1989, when Leipzig's persistent and non-violent form of protest finally communicated to the political rulers of the GDR that no weapons, however mighty, could thwart this new movement for freedom, peace in Leipzig was guaranteed – and maybe also in Europe. Leipzig was soon referred to as a boomtown where pressing problems were tackled more quickly than anywhere else. Since then the city's appearance has greatly altered. Leipzig is cleaner, more colourful and more beautiful – even if not every new edifice can be said to enhance the town's appearance. Leipzig is now so strongly dedicated to change and constancy, however, that also in this new epoch in its history the city shall take the best with it into the future.

Page 22/23:

Before houses in Leipzig were numbered in 1799 they were known by name only, indicated by a picture on the wall. The Goldene Hand or golden hand on Nikolaistraße dates back to 1713, although the building itself is from the mid 19th century.

Page 24/25:

Leipzig's two trade fairs used to sprawl out all over town. The many specialist exhibitions held here today are now tidily staged at the new fairground opened in 1996, its cleverly designed glass hall a popular focus of the proceedings.

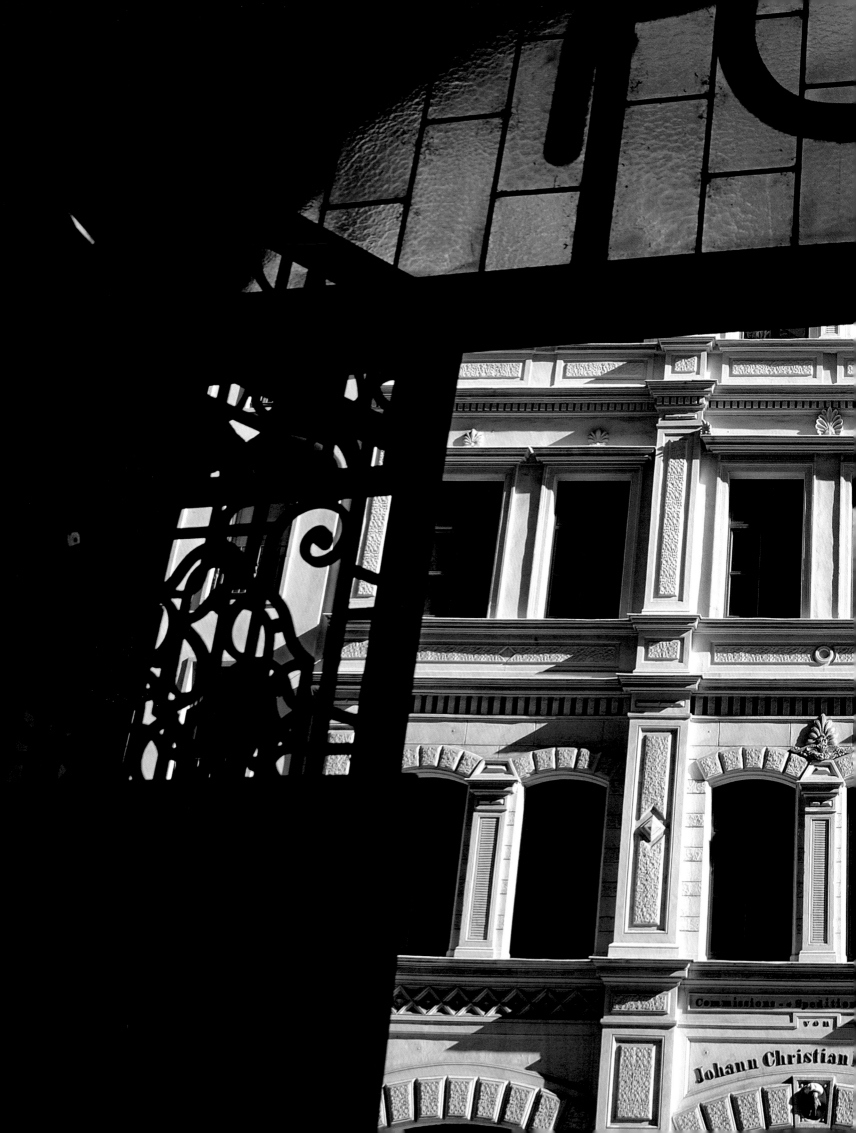

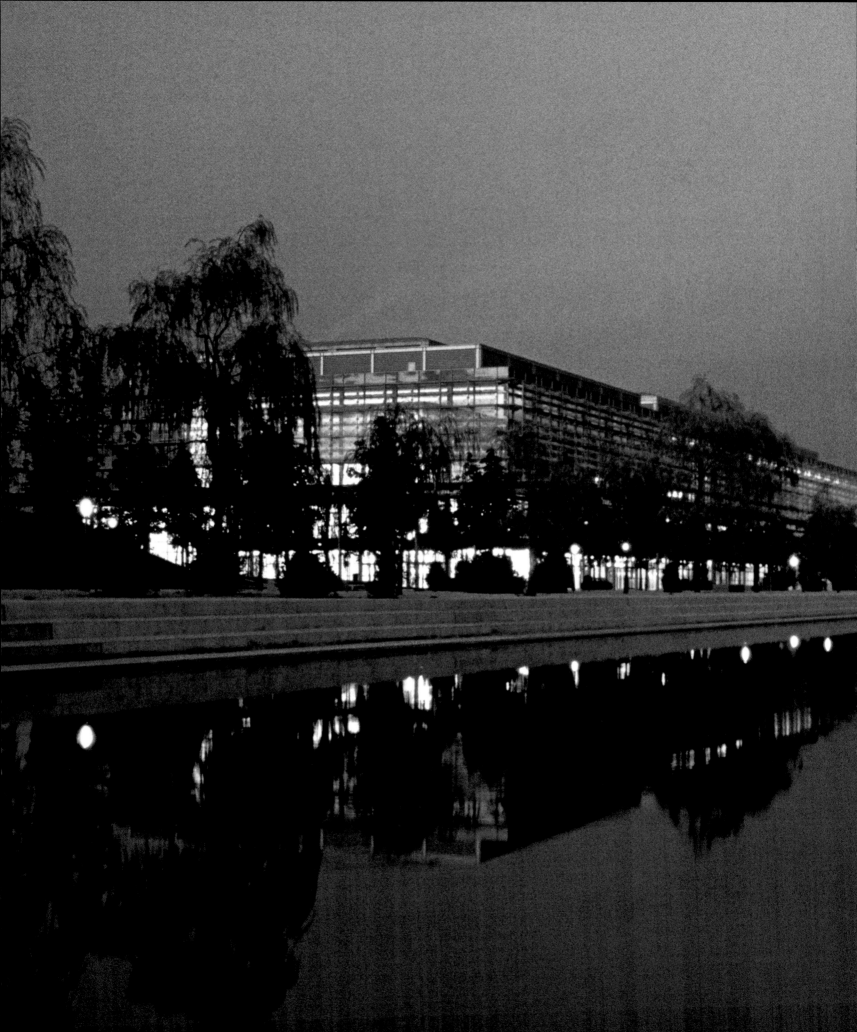

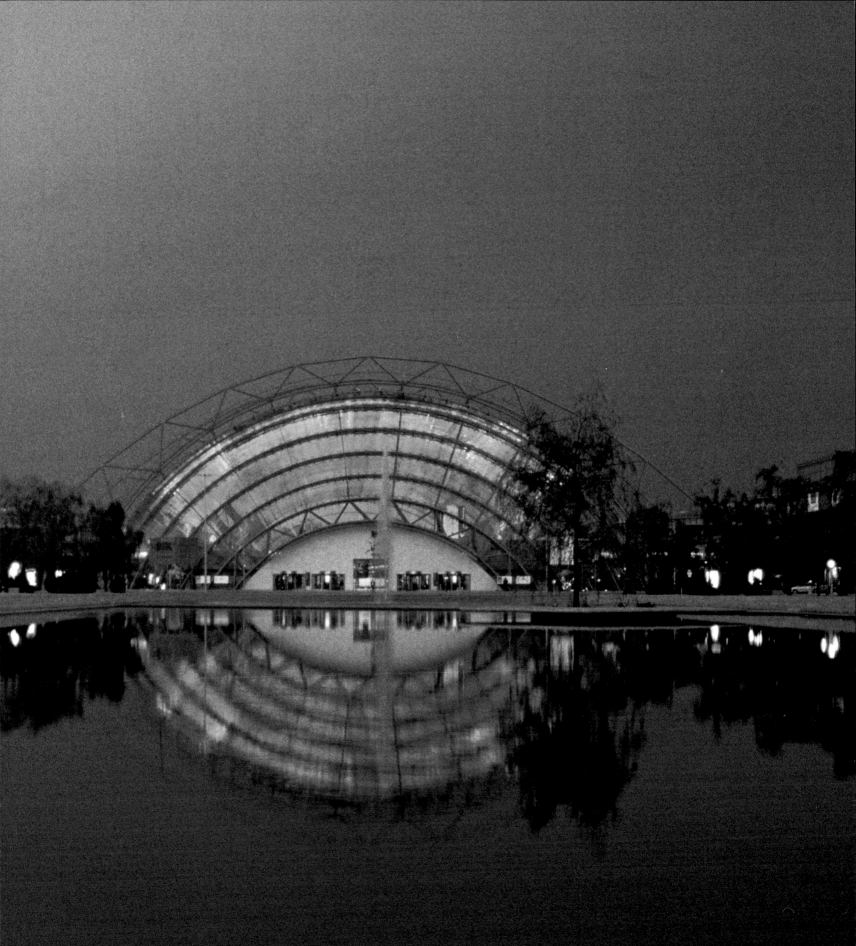

"Up town" – the centre

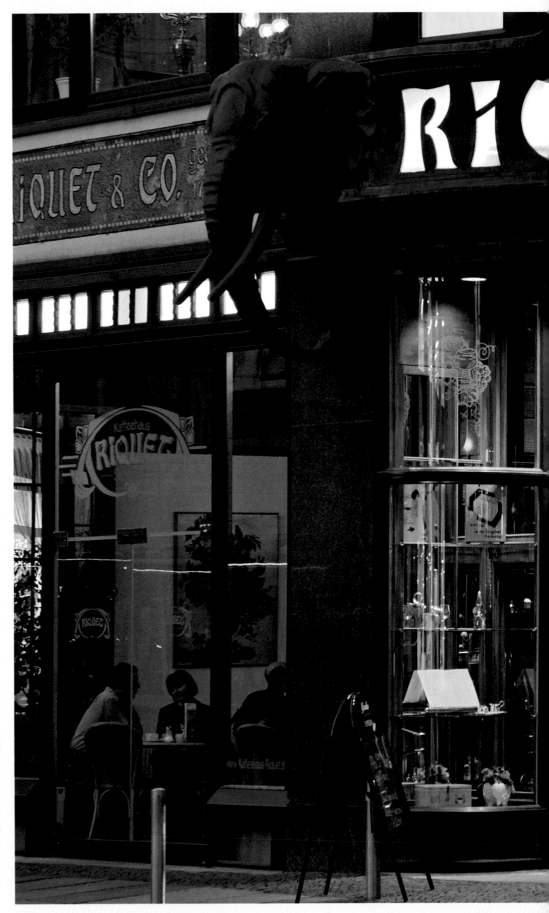

The Riquet-Haus from 1908/09 presents Leipzig as an intersection of north and south, of Wild West and Far East. The Huguenot trading dynasty once ensconced here used to do business with China, Japan and India, a fact mirrored by the elaborate and exotic design of the facade.

Since 1889 the city of Leipzig has experienced a positive wave of incorporations, meaning that it now consists of no less than 63 affiliated suburbs and villages which cover a total of 300 square kilometres (115 square miles). Although they're already in it, whenever one of the 500,000 inhabitants needs something in the old city centre they talk about "going up town" – as if it were a separate entity. The historic core of Leipzig, to which layer upon layer has been added down the centuries, is a concept embedded deep in the hearts of its residents.

Despite it being the eleventh-largest city in Germany Leipzig is not a hustling, bustling metropolis, instead engulfing guests and locals in an atmosphere which is both harmonious and rather nonchalant. Calling it "provincial", however, would enrage the people of Leipzig and really would be unfair. Leipzig is the "secret capital" – an epithet reminiscent of its strained relationship with the former residential capital of the Free State of Saxony, Dresden. During the days of the German Democratic Republic these words smacked of the confidence Leipzig demonstrated towards the official capital of East Berlin. Whether this boast is still justified in conjunction with Dresden or not is a matter for an impartial jury. The Saxons at least still adhere to the lasting validity of a turn of phrase from the 17th century: "Mined in Freiberg, sold in Leipzig – and squandered in Dresden." The reservations it voices betray not only a dry sense of humour but also have a historical background. Leipzig was never an ecclesiastical or worldly seat of residence yet Dresden, which was both, lived well off Freiberg silver and Leipzig trade. In an act of tit for tat, however, at the end of the 19th century the rulers of Saxony had their castle at Pleißenburg bought up by the headstrong burghers of Leipzig and the municipal Neues Rathaus symbolically erected in its place, its gilt gable still proudly proclaiming: "arx nova surrexit" (A new stronghold has arisen). Enter a new era.

Below:
The town hall has always
been multifunctional. For
centuries the ballroom
was used as a court of law
which is why the walls are
smothered with portraits
of local lords and chief
justices. Since 1909 the
Altes Rathaus has been
used as a museum
although special guests
are still received here with
due pomp and ceremony.

Right page:
The Altes Rathaus,
built in 1556, is Leipzig's
architectural showpiece.
Following the move of
the council to the Neues
Rathaus in 1905 the
Renaissance town hall
was turned into a museum.
During the course of its
refurbishment (1906-09)
the wooden arcade was
replaced by the present
stone one, made of
porphyry tuff from Rochlitz.

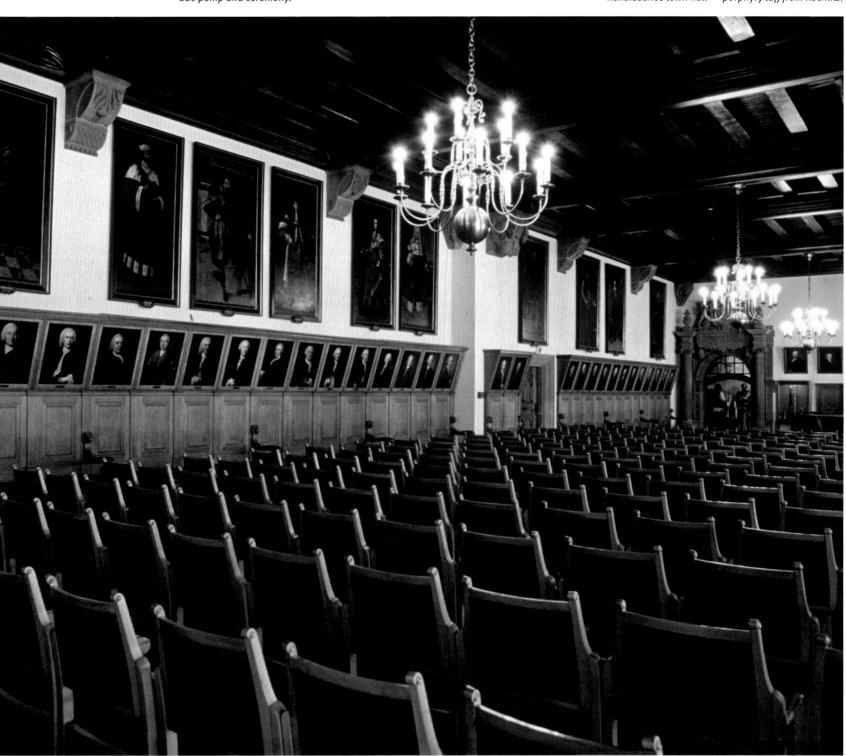

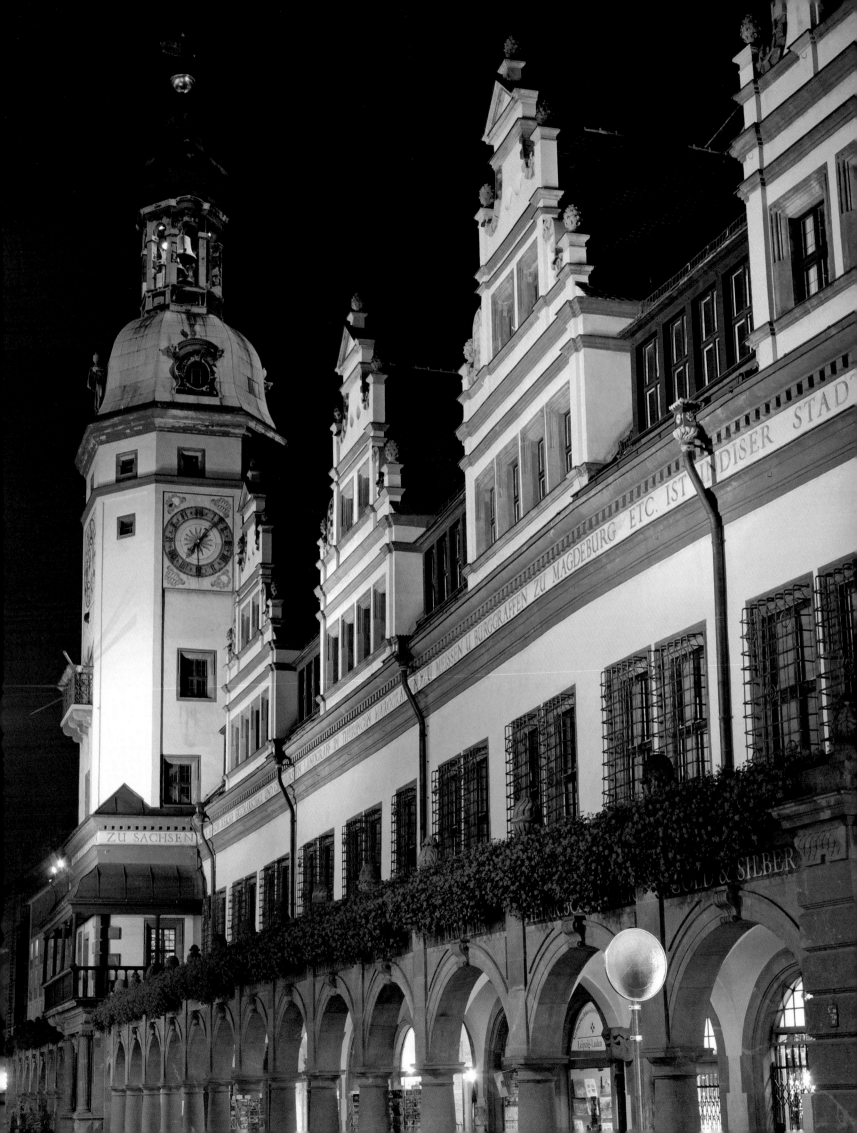

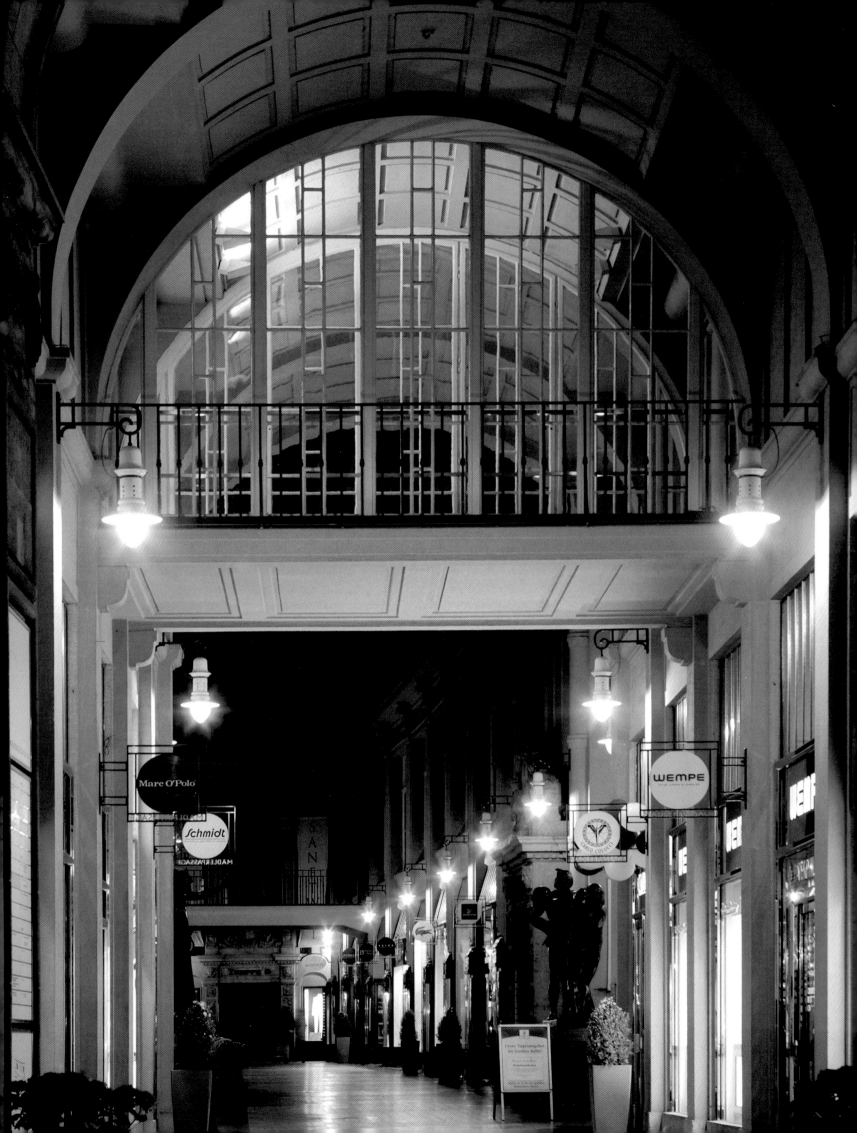

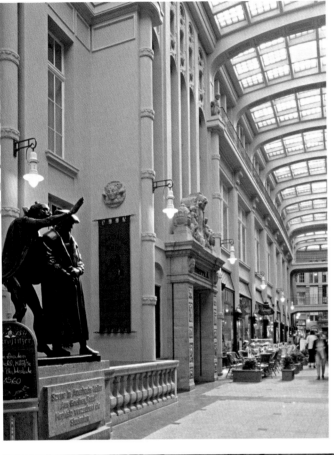

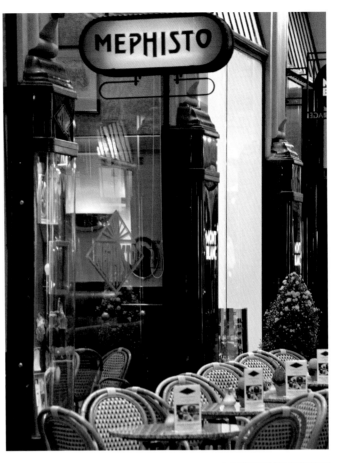

Left page:
Built on the site of Auer-
bachs Hof in 1911–13,
Mädler-Passage may not
be the oldest arcade in
town but is possibly the
most elegant.

Far left:
This bronze statue outside
the entrance to Auerbachs
Keller commemorates
the pub's two most famous
'guests': Faust and
Mephisto.

Left:
Even if it's raining you can
still enjoy a cup of coffee
'outside' in a pavement
café – under the protective
roofing of the Mädler-
Passage, for example.

Left:
Auerbachs Keller bang
in the middle of the
Mädler-Passage has been
serving wine since 1525.
The memory of Faust and
Goethe is sustained with
such enthusiasm here
that the pub has become
both a gastronomic
and cultural highlight
of historic Leipzig.

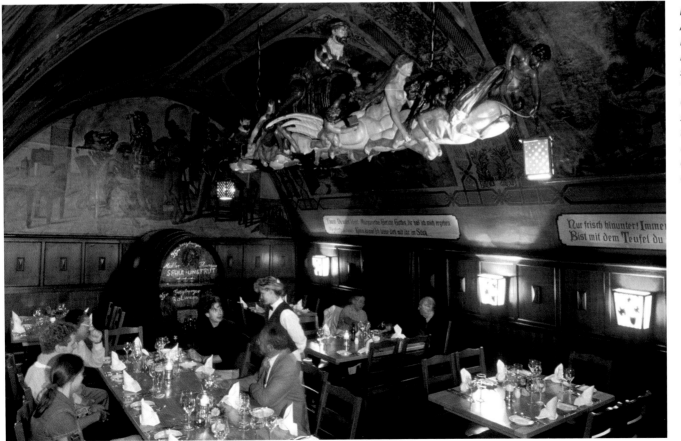

Above:
If you fancy a bop or just chilling out to some cool music, then Spizz on the ground floor and basement of the König-Albert-Haus on Markt/ Barfußgässchen is a good place to come.

Right:
On the top floor of the König-Albert-Haus allegorical figures represent the Saxon virtues of vigour and care, attributes also ascribed to King Albert (reigned 1873–1902).

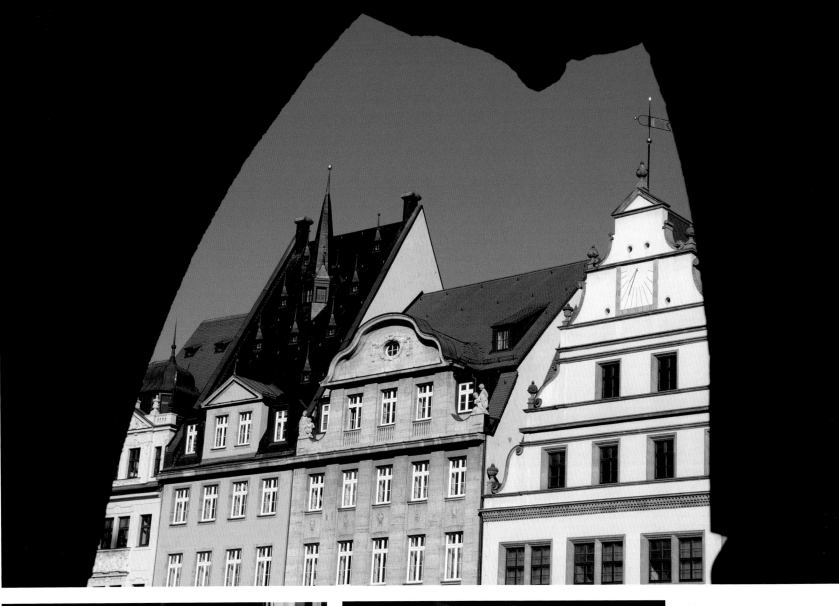

Above:
Buildings from various different centuries line the north end of the market place. Despite their diversity the Alte Waage (right, 1555), the Jugendstil house, a Gothic replica and the baroque Zum Weinstock still manage to form a pleasing ensemble.

Left and far left:
The shops tucked into the facade of the Altes Rathaus are tradition; the ground floor of the town hall has served as a retail outlet since its construction. Such an esteemed address is the perfect place to hunt down a few Leipzig specialities and some interesting second-hand books.

33

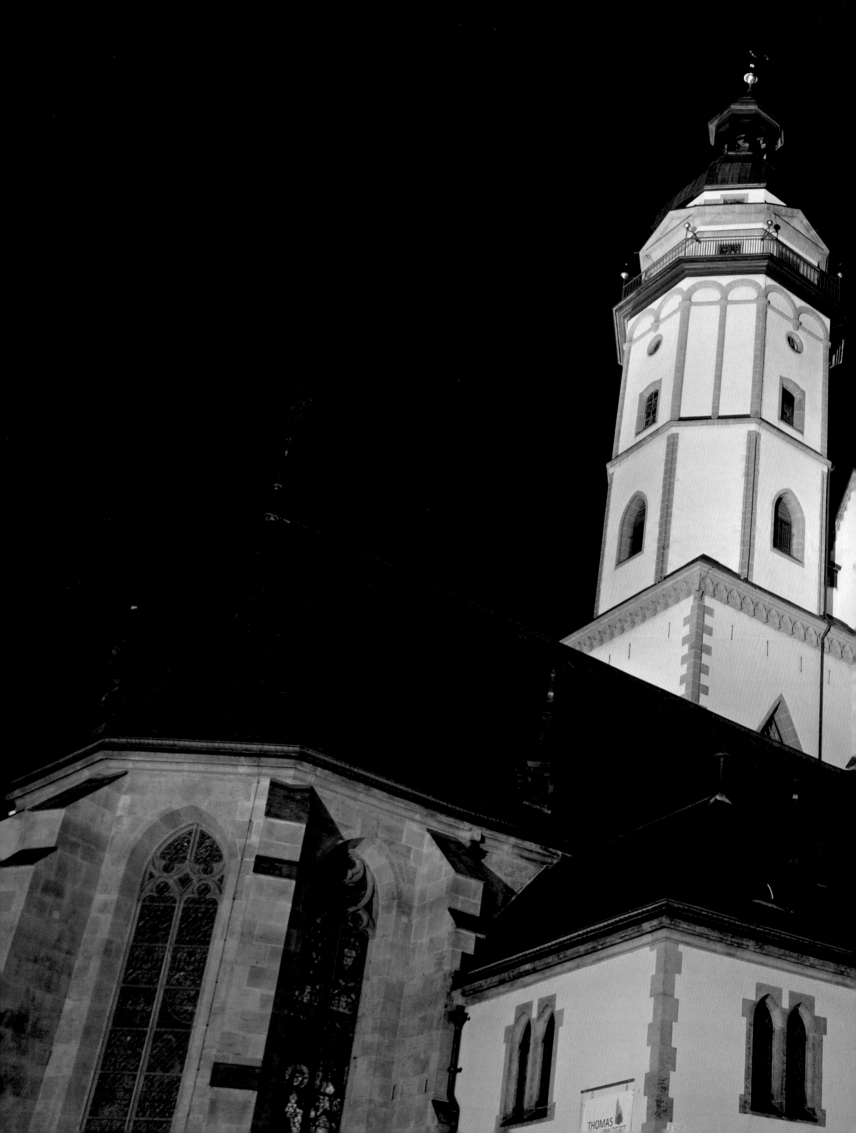

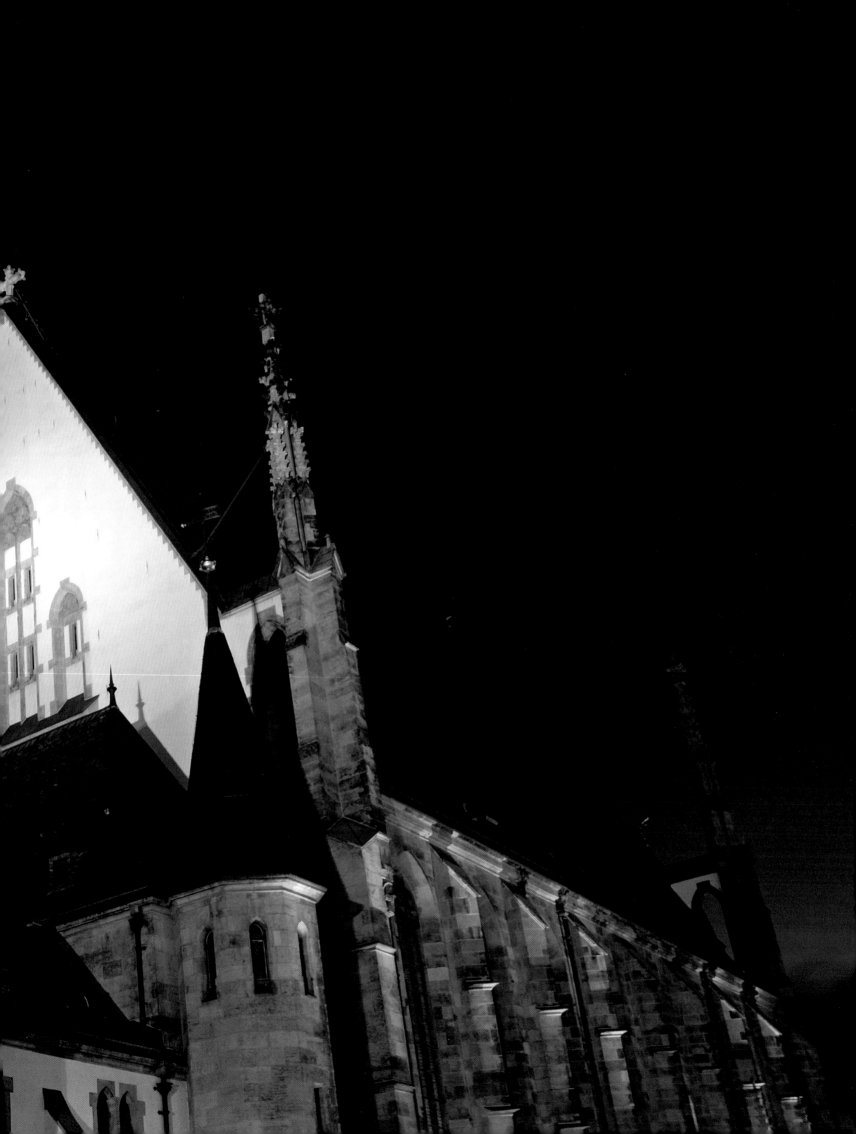

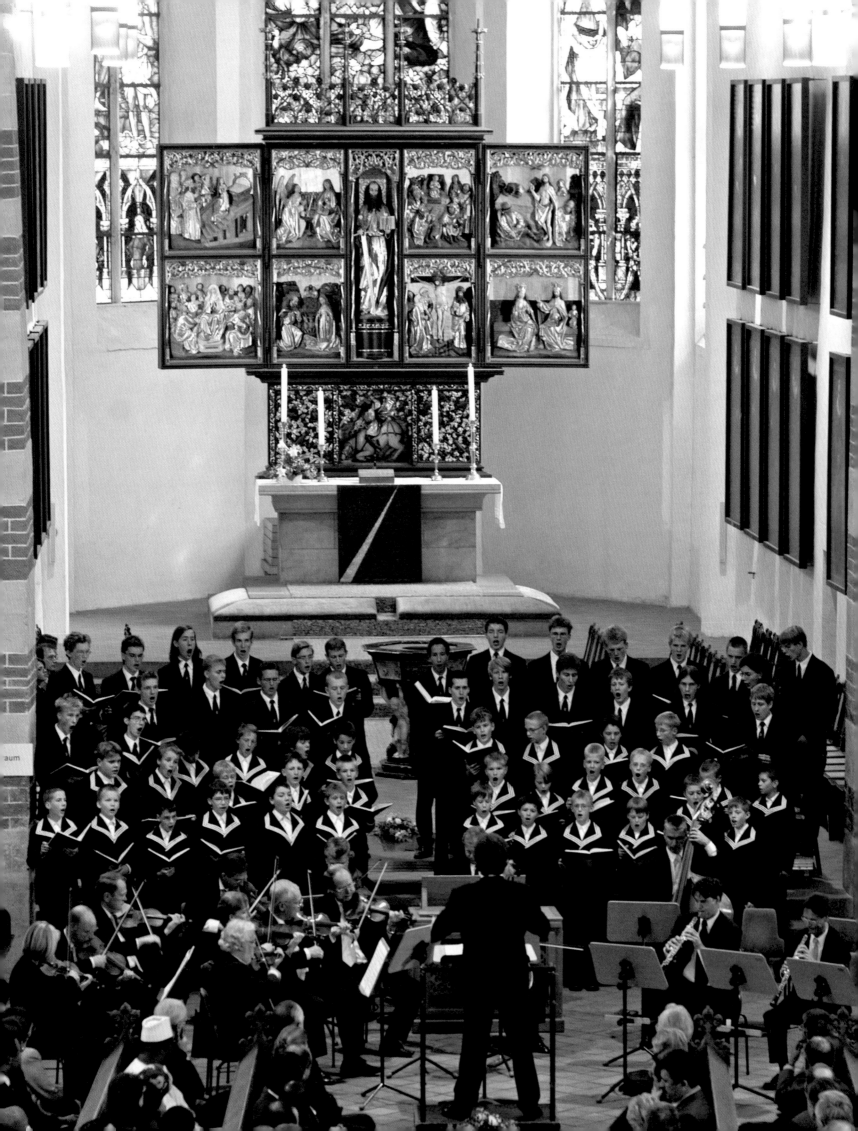

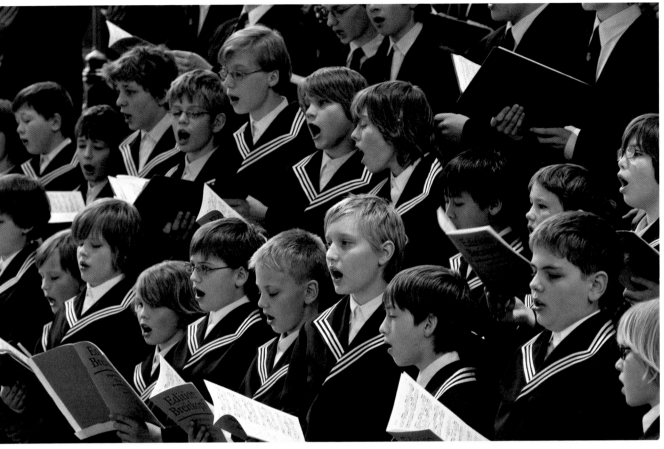

Page 34/35:
The Gothic hall church of St Thomas's was built in 1492–96 on the site of a smaller place of worship. The baroque dome was added in 1702, the Gloriosa bell inside cast in 1477. The area of the roof is huge; it would cover the entire market place.

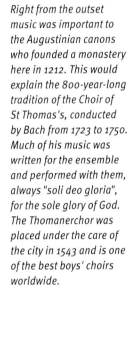

Right from the outset music was important to the Augustinian canons who founded a monastery here in 1212. This would explain the 800-year-long tradition of the Choir of St Thomas's, conducted by Bach from 1723 to 1750. Much of his music was written for the ensemble and performed with them, always "soli deo gloria", for the sole glory of God. The Thomanerchor was placed under the care of the city in 1543 and is one of the best boys' choirs worldwide.

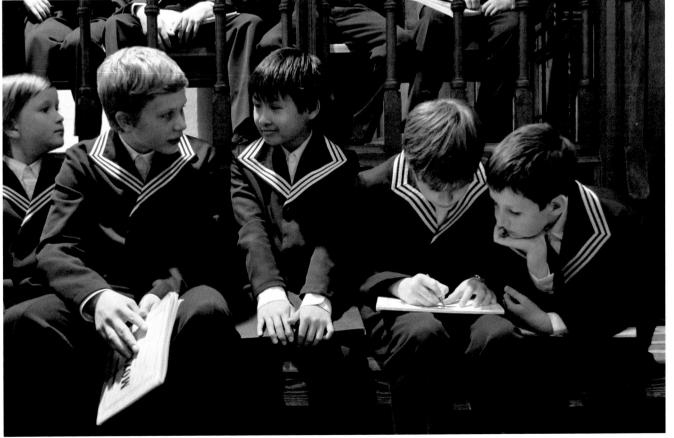

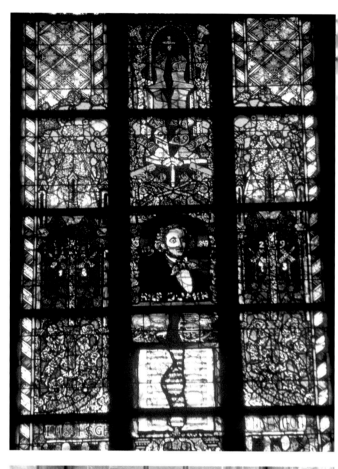

Right:
The neo-Gothic west portal was added to St Thomas's in the 1890s. Prior to this date any decoration was deemed unnecessary as the gable merely fronted town walls and fields.

Far right:
The stained glass window inserted into the south front of the Thomaskirche in 1997 is dedicated to Felix Mendelssohn Bartholdy, one of the great composers of Protestant church music. It's also to his credit that Bach was rediscovered during the 19th century.

Right page:
Since 1950 Bach's mortal remains have been interred in a special vault in the chancel of the church which is about a century older than the nave. His body previously rested in the Johannis- kirche which was destroyed during the Second World War.

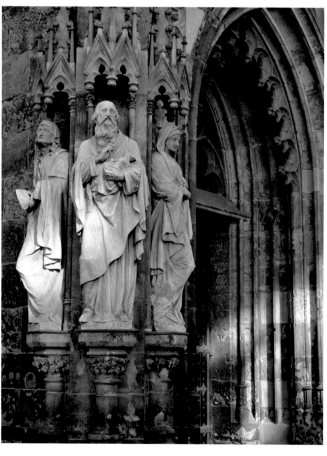

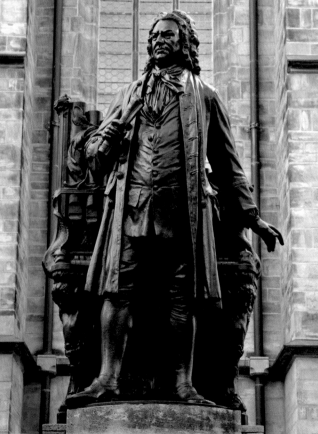

Right:
The apostles' doorway on the north side of the church also dates back to its neo-Gothic period of refurbishment.

Far right:
Outside the church is the statue of Bach from 1908. The portrait of the musical genius was reconstructed by sculptor Carl Seffner and anatomist Wilhelm His on the discovery of Bach's skeleton in 1894. The older Bach memorial, just a few paces away, was erected on the initiative of Mendelssohn in 1843.

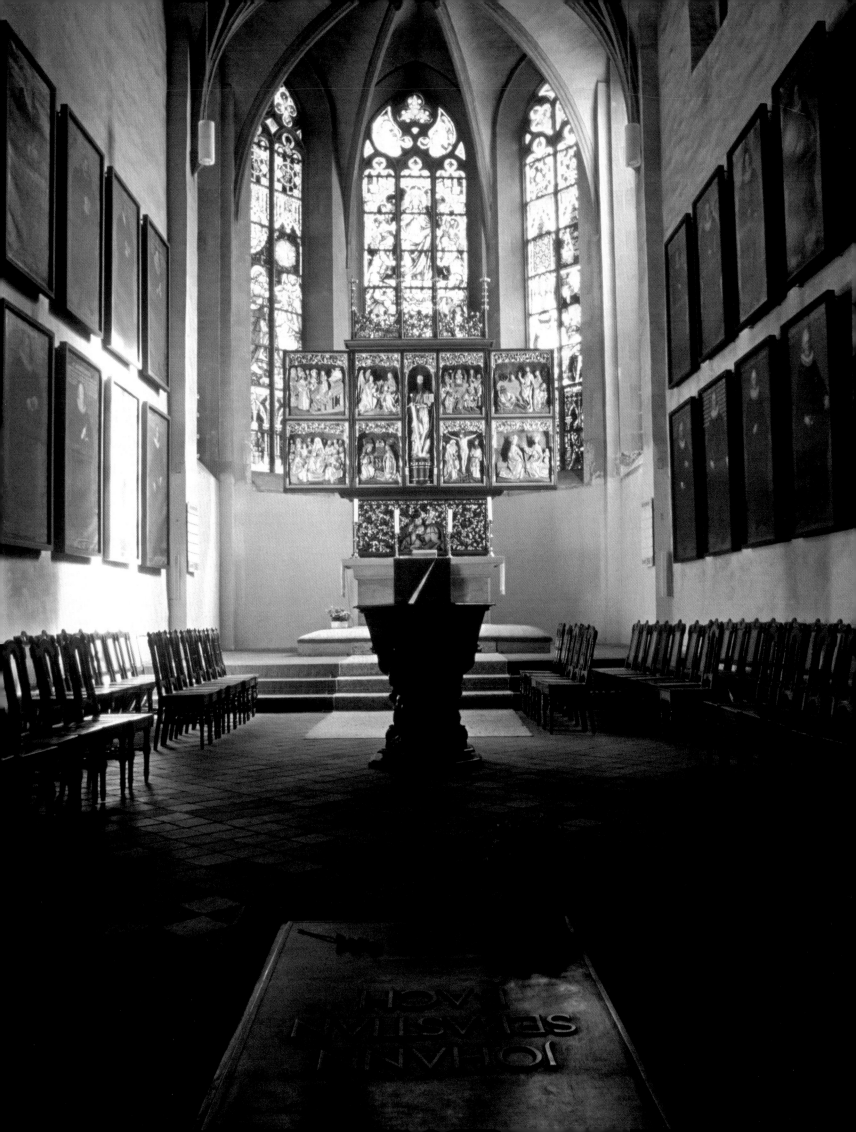

Above:
The beautiful Rococo Altes Kloster building was erected on the site of the old monastery of St Thomas's on Klostergasse in 1754/55. When ten years later Goethe enthused about the modernity of Leipzig he probably also had this edifice in mind.

Right:
The Italian Renaissance celebrates its reincarnation Saxon style on Schiller-straße. During the 19th century the burghers of Leipzig turned their architectural attentions to historical styles of building, naming their first grand promenade lined with such after the 'commoner' Friedrich Schiller. This didn't go down too well with the royal court in Dresden ...

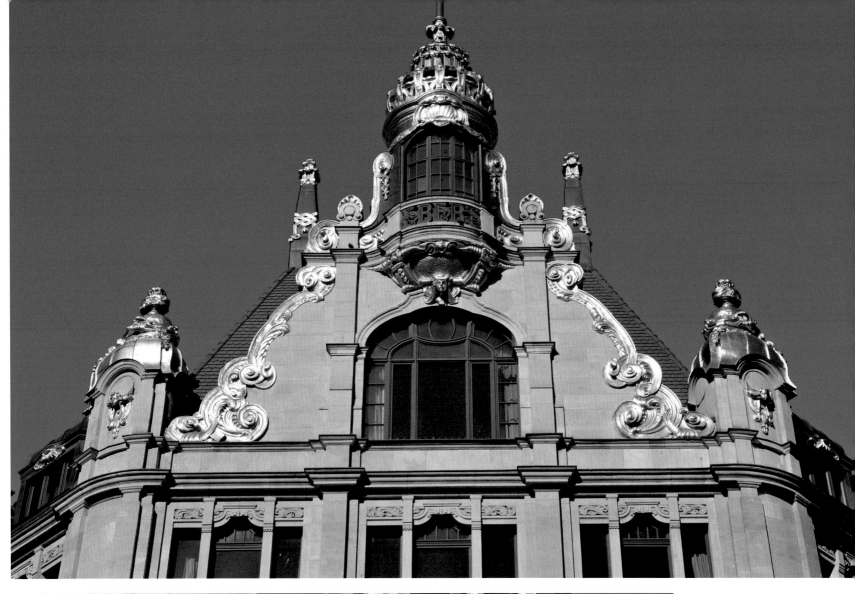

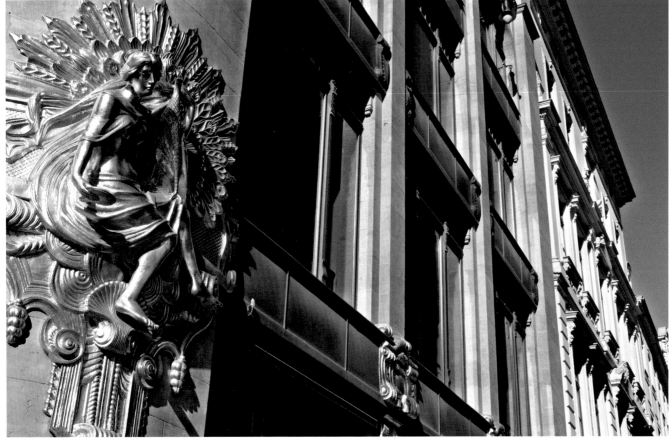

Above:
This building now used by a major bank was built in 1903/04 as Kaufhaus Ebert. It manages to successfully fuse elements of both the baroque and German Jugendstil.

Left:
Doing a pretty fair impression of Goldilocks, the pretty girl superimposed onto the corner of the clothes store represents the female attributes of Beauty and Grace. Her opposite number at the other end of the building, her companion a peacock, is a rendition of Vanity.

Town halls, stock exchanges and houses of God – architectural Leipzig

The Altes Rathaus is not the oldest in town. This stood on the same site but in February 1556 had to make way for the building which since 1905 and the opening of the Neues Rathaus has been known as the 'old' town hall. Assembled in a record time of just nine months the edifice gave rise to vicious speculation; Hieronymus Lotter, the architect, was said to have constructed it without plans, earning it the nickname of *Lotterwirtschaft* or "slovenly mess" which has stuck to this very day. This is as much hearsay as the claim that it was built so fast it would soon have to be completely renovated. The first major restoration work was only carried out on it 116 years later. This incidentally set a second record; an inscription was carved into the facade which is absolutely unique in that it runs around the entire building. It honours the local ruler while quoting Psalm 127: "Where the Lord does not build a city those who build it work in vain. Where the Lord does not watch over the city the watchman watches in vain." The Altes Rathaus had room for a council chamber, various offices, a dungeon and penitent's cell and salesrooms. There wasn't, however, enough room for a Ratskeller or place to dine. The saying that someone's as busy as the council of Leipzig is thus possibly rooted in the fact that here it was all work and no play, the mounds of administration including the jurisdiction meted out by the high court accommodated here. Councillors wanting to order or free their thoughts over a glass or two of council wine thus had to trot over the road to their very own tavern, the Ratsherrentrinkstube tucked into the Ratswaage building. This weigh station was where much of Leipzig's wealth was made, where goods travelling to and from the trade fairs were both weighed and taxed in a municipal operation which proved extremely lucrative.

Behind the Altes Rathaus on Naschmarkt, where butchers, bakers and gardeners from the surrounding area sold their wares, is the stock exchange. Even if the fine Renaissance town hall with its perfect proportioning (its tower divides the facade according to the principle of the golden mean) was rather effusively counted among the seven wonders of the modern age, tastes changed in the hundred years following its construction. Leipzig merchants who sold stocks and shares in ramshackle wooden huts had seen buildings in the major trade centres of Western Europe which mirrored the new general sense of *joie de vivre*, buildings adorned with balustrades, sculptures and garlands of stucco fruit. In the same vein they now constructed a suitable abode for their business dealings: their very own stock

exchange or Handelsbörse, the first baroque building in Leipzig which was to serve as an example in the design of the many mercantile palaces and town dwellings to follow.

Zur goldenen Schlange

Many of the buildings in Leipzig are inextricably linked to its history of trade and commerce. One of the huge merchandising inns which still remains is the one known as Zur goldenen Schlange or Barthels Hof. At the corner of the market place and Hainstraße wagons could be driven in one end of the courtyard and out again the other side onto Kleine Fleischergasse once they had unloaded. The ornate late Gothic oriel once embellished the market place facade; when the building was modernised in 1870/71 it was moved to the courtyard – as luck would have it, for in doing so it was preserved. Another case where an older building has thankfully survived various refurbishing attempts is the Fregehaus on Katharinenstraße; the ground floor with its late Gothic portal has a baroque rump. Without exception the mercantile mansions of the past century are now used for other purposes. The great significance trade once held for the architecture of Leipzig is most obvious when we wander through the old shopping arcades or *Passagen*, the 'modern' successors of Leipzig's old trading inns. They were based on French and Italian models whose elegant combination of street trade and yard sale with in-store retail held great appeal for the discriminating clients of Leipzig.

As in many other cities whose history is dominated by the turnover of various goods the main church in town is dedicated to St Nicholas, the patron saint of merchants and businessmen. The oldest building in the Altstadt, the Nikolaikirche has undergone many changes in its long history which dates back to the 11th century. The most spectacular was the redesign of the nave in the neoclassical vein in 1796. The international pinnacle of its career as a place of worship was in 1989, however, when images of people peacefully praying and successfully negotiating beneath decorative palm pillars were beamed onto TV sets across the globe.

Left:
The elegant playfulness of the Jugendstil period is captured by the details on Kaufhaus Ebert, such as this supra porta sculpture of a girl's head.

Above:
Walking through Leipzig is like travelling back through time – architecturally at least. On Dittrichring the Gründerzeit is most prevalent, the foundations of many of its splendid villas resting on the remains of the old city walls.

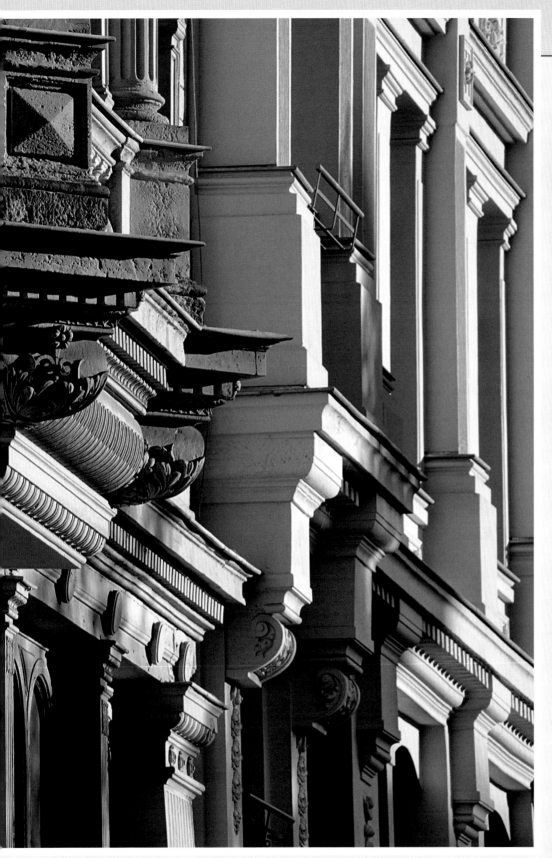

Top right:
The balcony and turret on the Zur goldenen Schlange building are products of the transition between Gothic and Renaissance in 1523. During rebuilding work in 1870/71 they were moved from the market front to overlook the courtyard, ensuring their conservation.

Centre right:
The neoclassical coffered ceiling (1797) in the Nikolaikirche hides the older Gothic fan vaulting. The stucco pillars also shroud the original Gothic supports.

Right:
The old dyed thread works from the 1880s has been turned into an attractive business and residential complex along the banks of the Elster River.

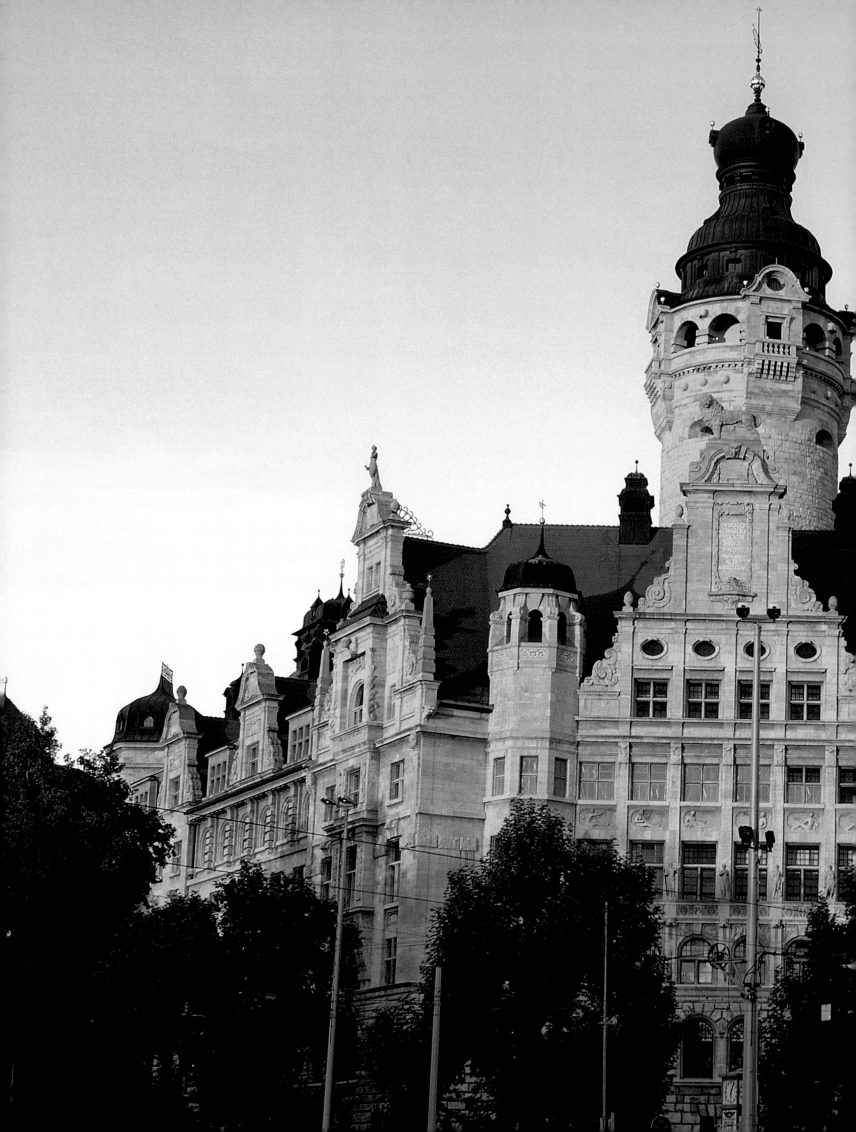

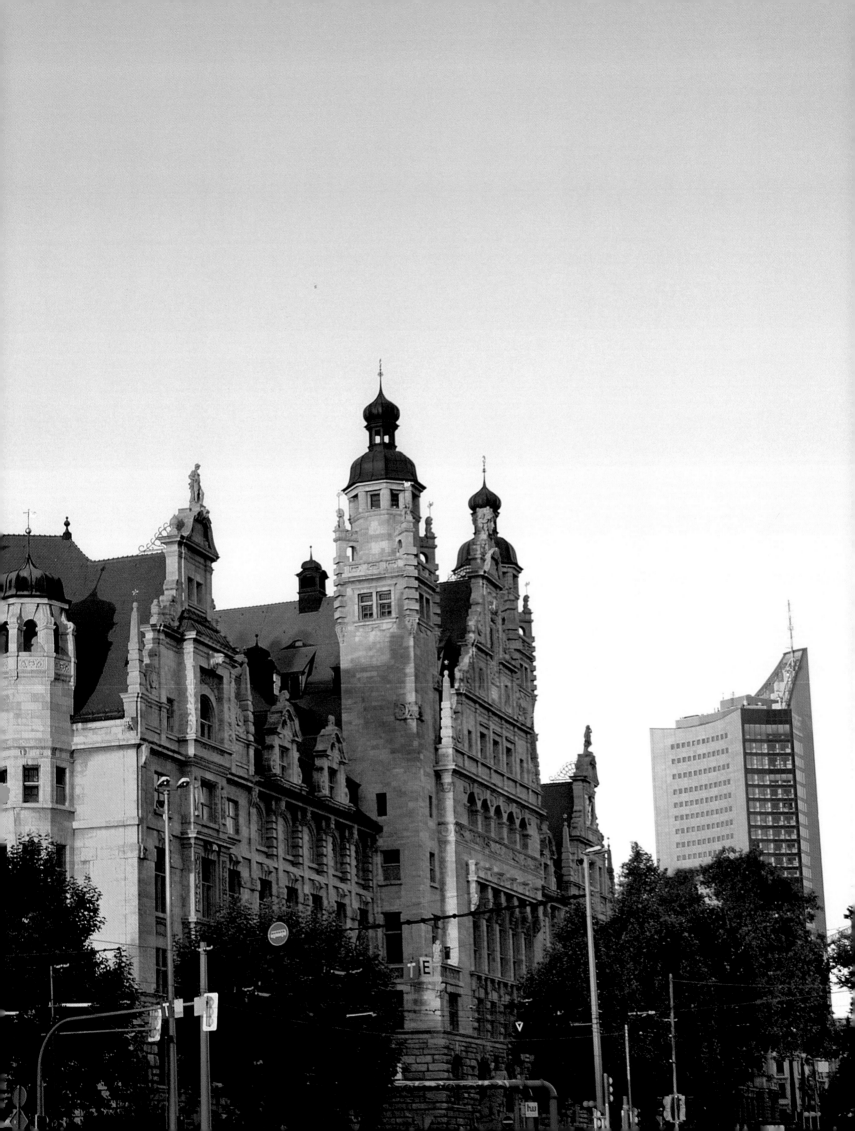

Page 44/45:
When at the end of the 19th century the Altes Rathaus was bursting at the seams no suitable spot could be found for a new building in the city. The rich and confident burghers of Leipzig thus bought up the royal fortress of Pleißenburg, tearing it down to make room for the gigantic Neues Rathaus.

Right:
With his Neues Rathaus which opened for business in 1905 architect Hugo Licht has created a building which quotes details from practically every period in architectural history. The wrought iron gates to the main entrance are crowned by a pelican, the ancient symbol of care and welfare.

Right page:
The southwest front of the Neues Rathaus is without doubt its most prestigious aspect. The mayor's balcony runs along the entire facade, the allegorical figures on the balustrade depicting the strengths of Leipzig: (from left to right) the printing of books, justice, science, art and industry. The gable bears the Latin inscription: "[For] public counsel [and] public wellbeing 1899–1905".

Right:
The stairs leading up to the main entrance are proudly guarded by mighty Leipzig lions made of Muschelkalk from Main-Franconia.

Far right:
This relief of Caritas speaks both the stylistic and symbolic language of the Jugendstil period. Here she stands for maternal love, personifying a city which is both willing and able to nourish and care for its citizens.

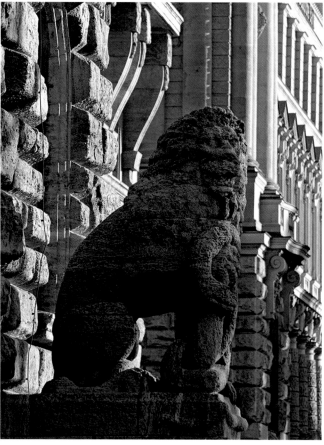

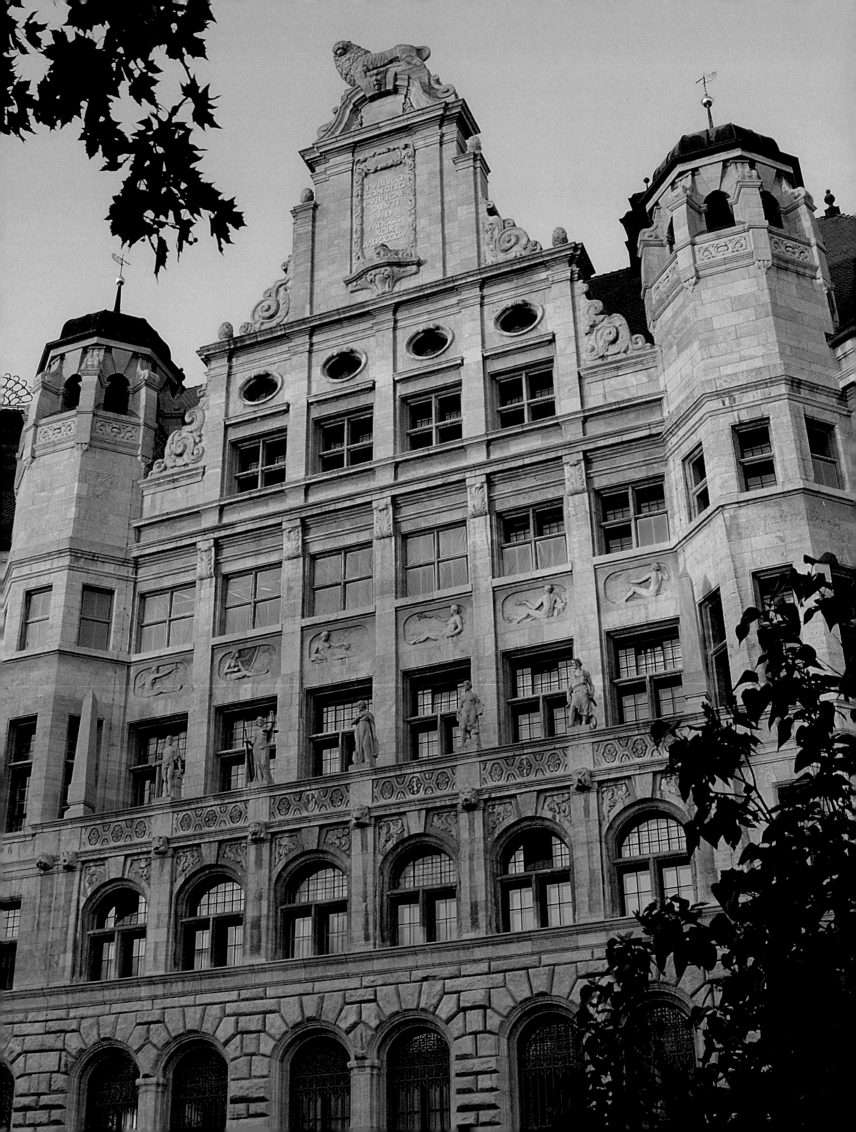

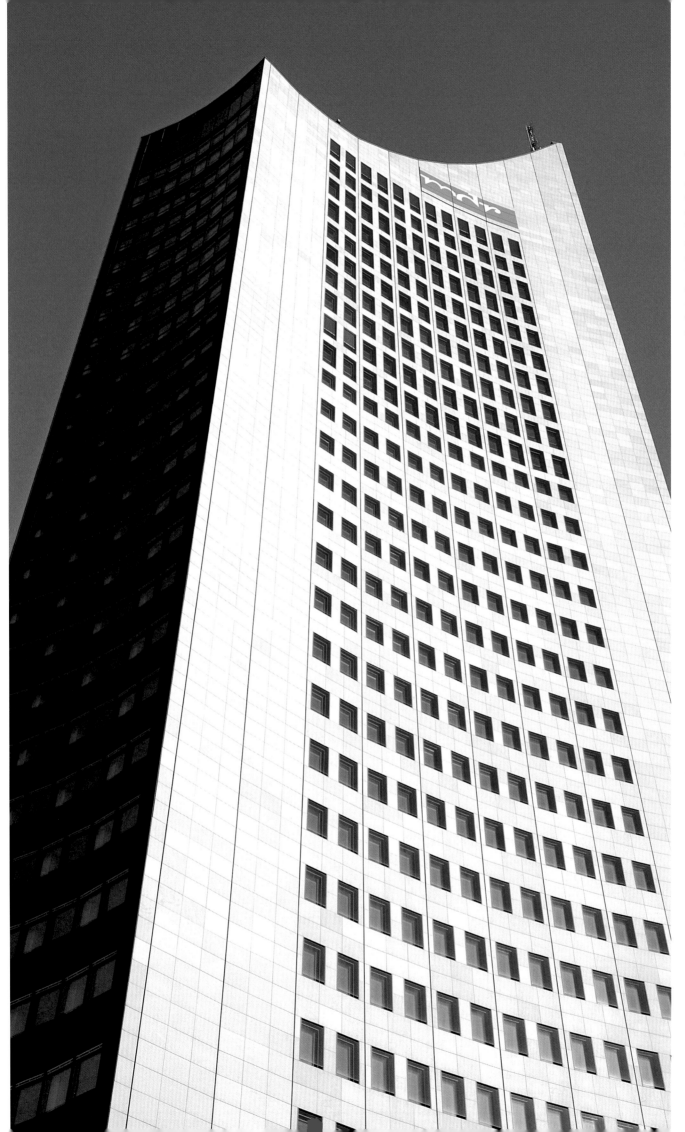

Left:
The City-Hochhaus, built in 1968–72 as the administrative headquarters of the university, was turned into offices during the 1990s. The original aluminium facade was replaced in stone. From the restaurant on the top floor there is access to a platform 120 m (394 ft) above the city.

Top right page:
On a fine day there are grand views out across the city and the basin of Leipzig from the top of the skyscraper. A signpost gives the general direction of other landmarks.

Bottom right page:
If you've not got a head for heights, you might feel more comfortable in the historic cellar of the Moritzbastei close to the base of the City-Hochhaus. Originally built as casemates serving the fortress in the 16th century, the vaults were turned into a student club in the 1970s.

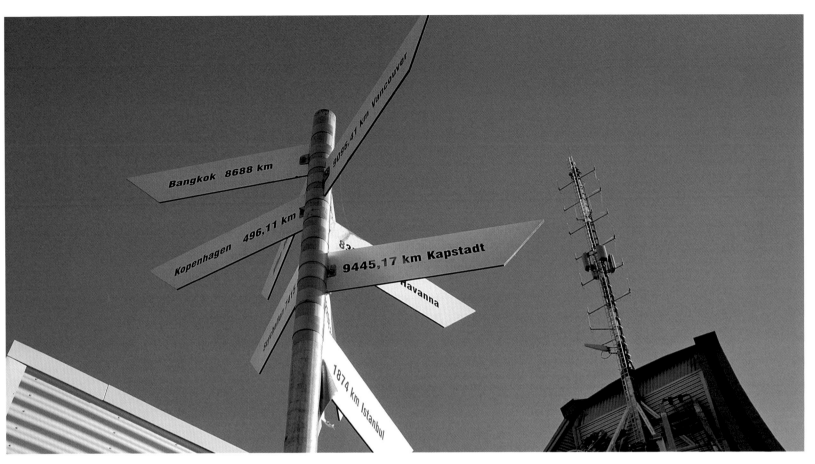

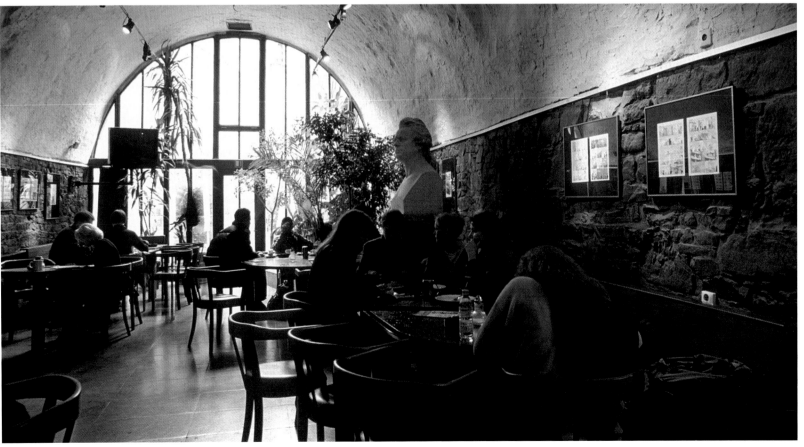

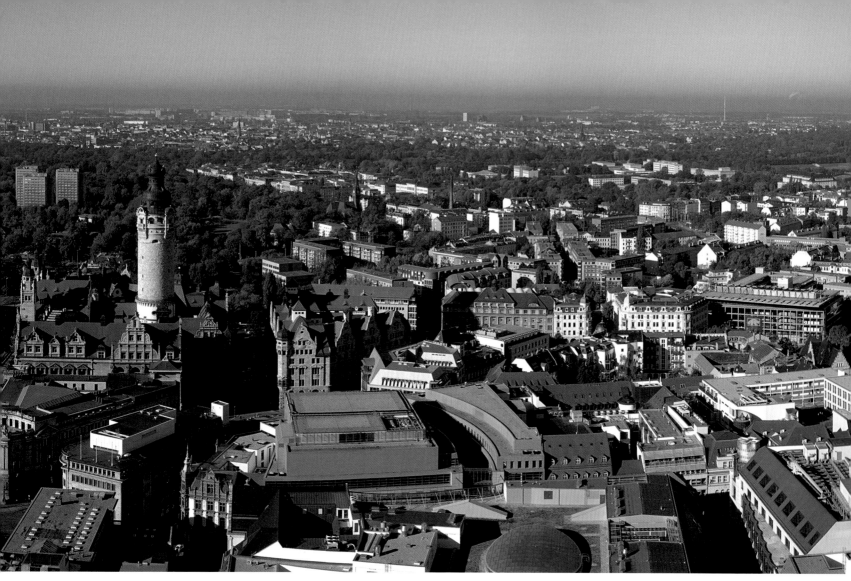

Above:
The city panorama towards the west. Looking right from the Neues Rathaus (left) you can see the Petersbogen offices, the Thomaskirche, the market place and The Westin Hotel. On the horizon you can just about make out the airport control tower.

Right:
After the war the supreme court building acted as both a museum of the fine arts and as a permanent exhibition hall on the case on the burning of the Reichstag which was held here.

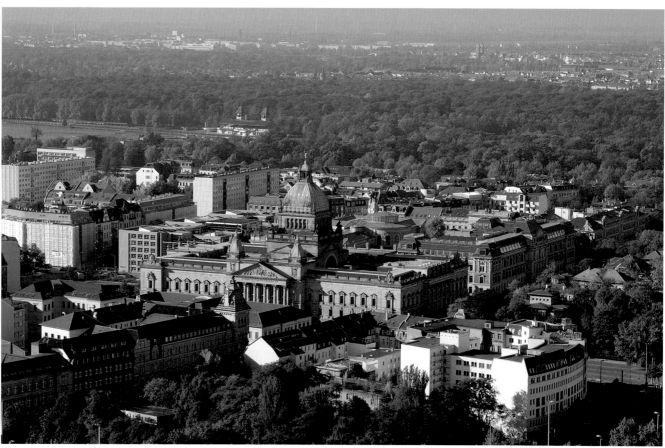

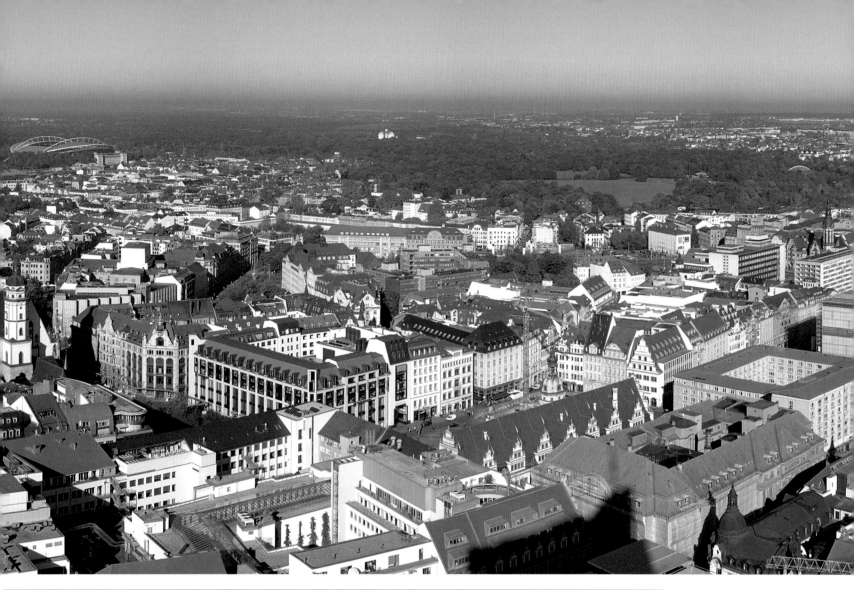

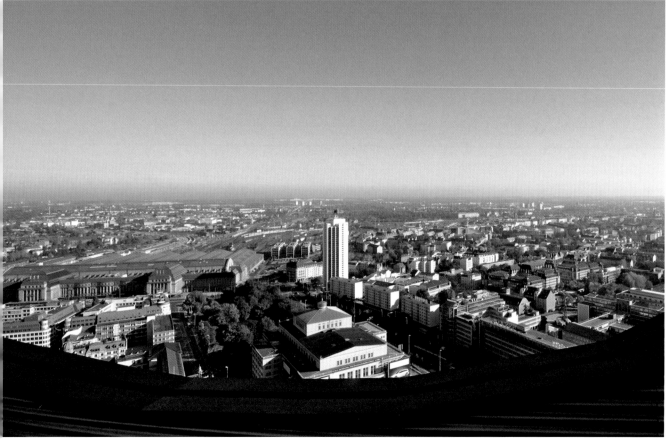

Left:
The view from here really is magnificent, bringing to mind the words of tower watchman Lynkeus in Goethe's "Faust": "Born to see / To watch employed / Sworn to the tower / I love the world."

Page 52/53:
Augustusplatz used to be considered the most beautiful square in Leipzig; now it's just the biggest. All of its grand 19th-century buildings were destroyed in the Second World War. The City-Hochhaus and concert hall (left) are products of the 1970s/1980s, the colossal cylindrical ventilating shafts in the foreground an unfortunate addition.

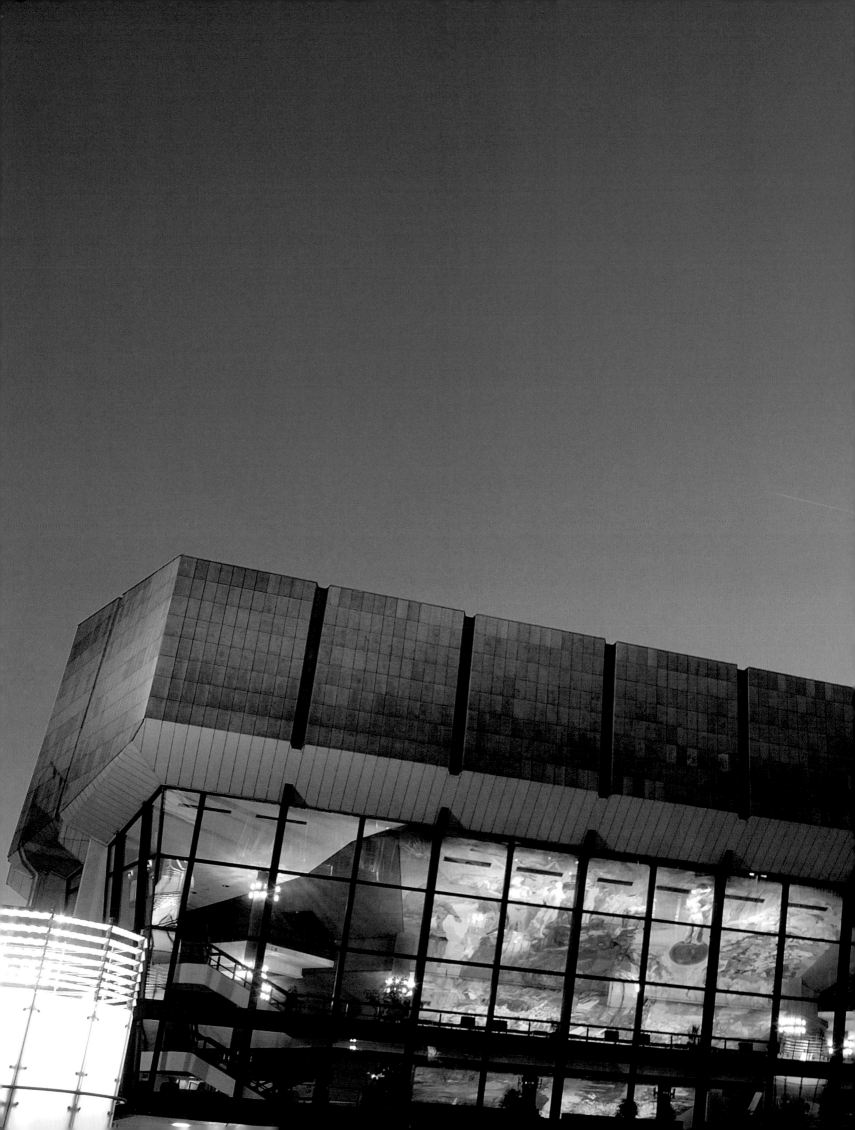

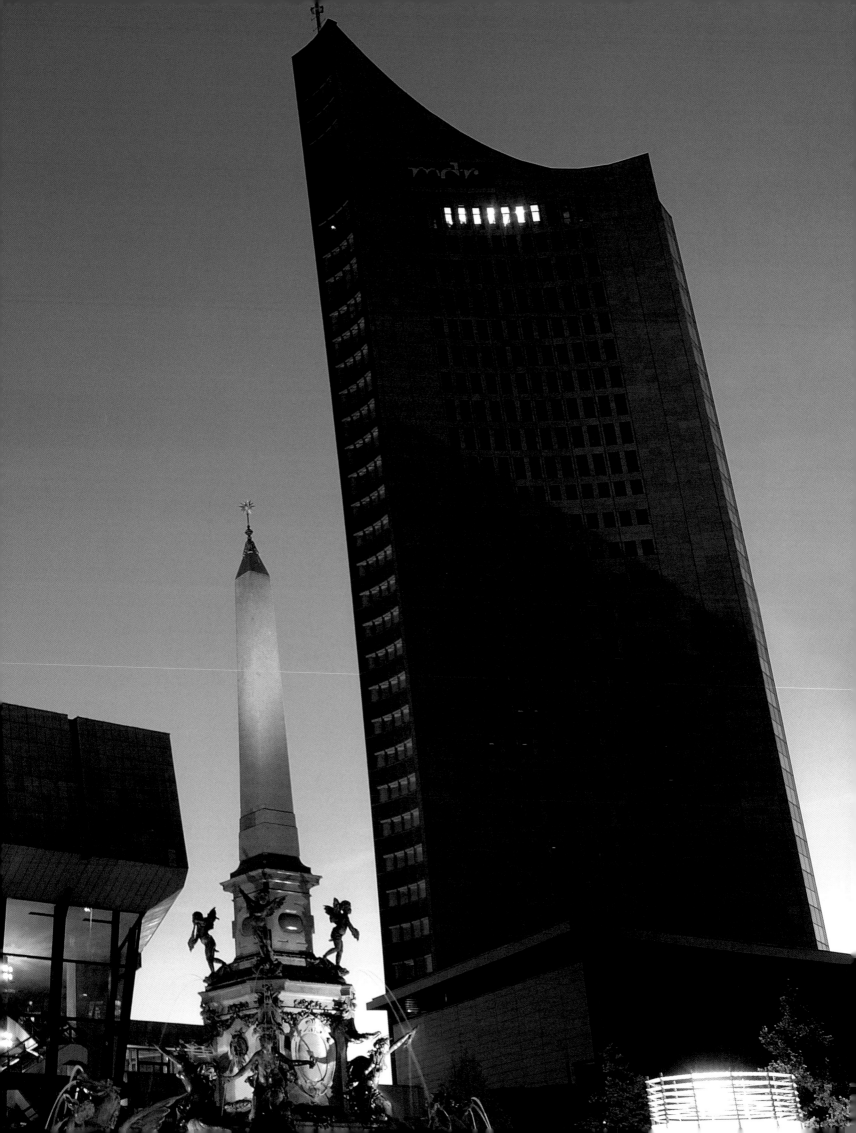

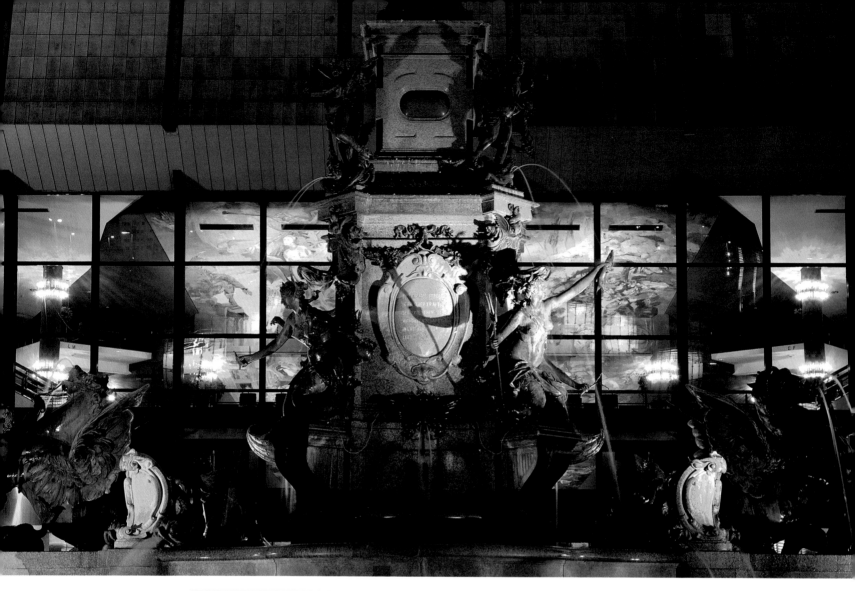

Above:
The Mende Fountain from 1886, a gift from merchant's widow Marianne Pauline Mende, tinkles gently outside the Gewandhaus. Fabled figures from Greek mythology, tritons and hippocamps, dolphins, nereids and cherubs are grouped around a granite obelisk.

Right:
The view from the stage in the Großer Saal of the Gewandhaus reveals terraces of seats arranged like a vineyard. This is the home of the Gewandhausorchester; many other great ensembles also love to play here for the excellent acoustics.

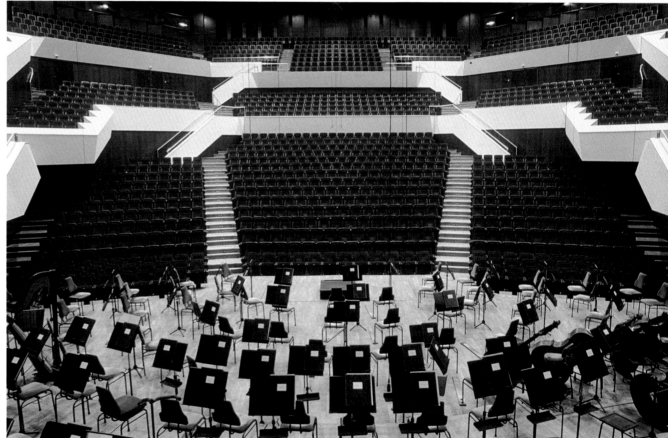

Left:
The opera house on Augustusplatz was built in 1959/60 on the site of the Neues Theater bombed during World War II. The sharp lines of the architecture lend the building a dignified severity. Not far away is a skyscraper built in 1969–74 which with 30 floors is the highest residential building in town.

Below:
Leipzig's first skyscraper was erected for banker Hans Kroch in 1927/28. It was modelled on the Torre dell'Orologio in Venice whose clock is quoted here. The Latin inscription reads: "Work conquers all."

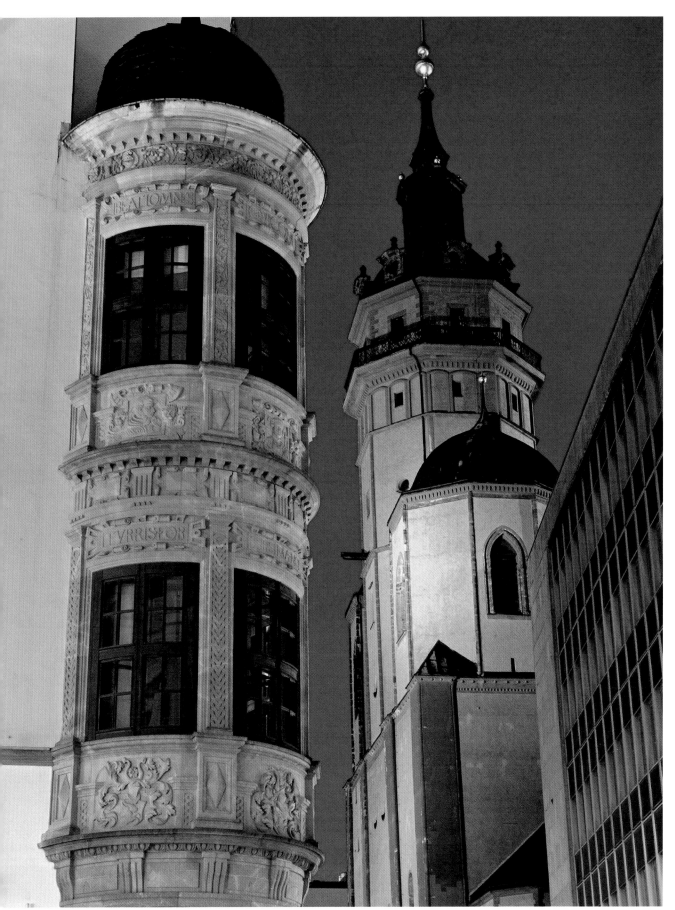

Left page:
Whatever perspective you
see it from, the baroque
cupola of the Nikolaikirche
on its Romanesque base
forms a crass contrast to
the other buildings round-
about. The turret on the
Riquet-Haus, for example,
reminiscent of an Asiatic
pagoda, is most definitely
Jugendstil.

Left:
The two-storey round oriel
made of porphyry tuff
from Rochlitz in 1588 (this
is a copy) is the work of a
Renaissance mason. It
originally adorned the
Fürstenhaus on the oppo-
site side of the street which
was pulverised during the
Second World War. In the
background is the steeple
of the Nikolaikirche.

Page 58/59:
The Nikolaikirche first
existed as a place of
prayer serving the
merchant community
of the 11th century before
the basic outline of the
present building was
laid out in the 12th. Now
Leipzig's chief hall of
worship, its design has
been modified many
times by citizens keen to
emulate the stylistic fads
and fashions of their day.

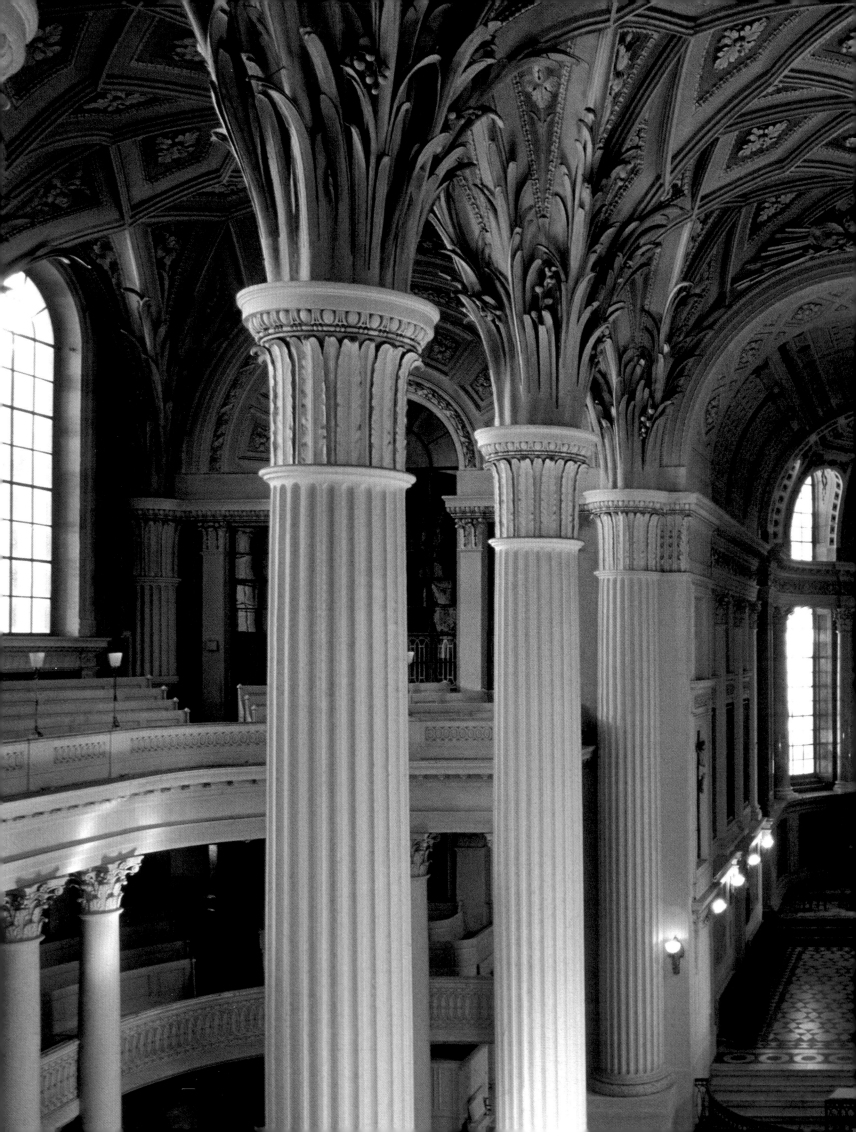

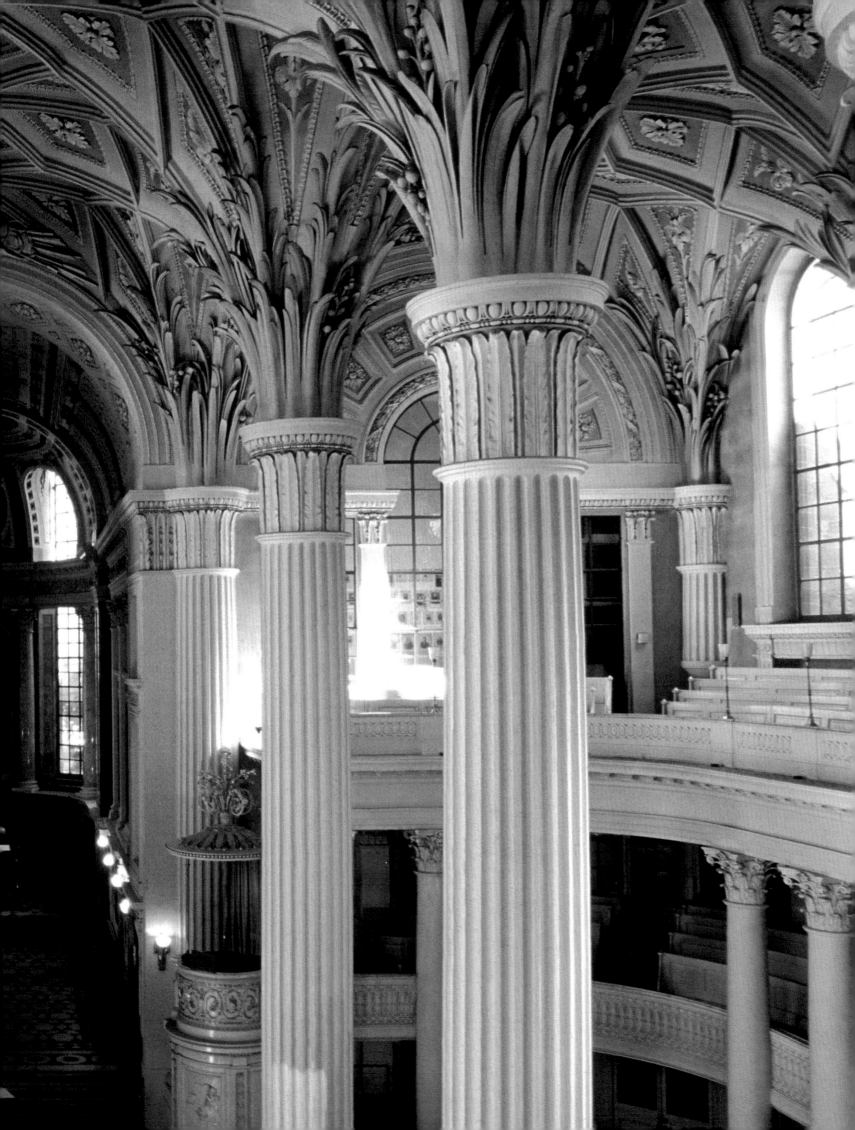

Right:
On Nikolaikirchhof, the historic square in the heart of town, stands the Nikolaischule, built in 1512 and much altered over the years. In 1989 hangers-on of the Stasi burst out of the school and attacked demonstrators outside the church. It's thus highly symbolic that the Kulturstiftung Leipzig, generously supported by their twin town Frankfurt am Main, decided to save this particular building, restoring it in 1991–94.

Right page:
Nikolaikirchhof is dominated by a copy of one of the pillars in the Nikolaikirche. Instigated by Leipzig artist Andreas Stötzner, it was erected by the Kulturstiftung Leipzig ten years after the astounding event of October 9, 1989. The pillar on the square symbolises movement and transition – from the sanctuary of the church within to the hostile yet hopeful world without.

Right:
The preacher's house on Nikolaikirchhof was built to house the pastors of the Nikolaikirche by Hugo Licht, the architect of the Neues Rathaus, in 1886/87.

Page 62/63:
Up until the 19th century Naschmarkt was where the daily staples were sold: bread, meat, vegetables and also textiles and shoes. It's now one of the most prominent squares in town where in 1903 a monument was erected to Goethe – himself rather less prominent during his time in Leipzig.

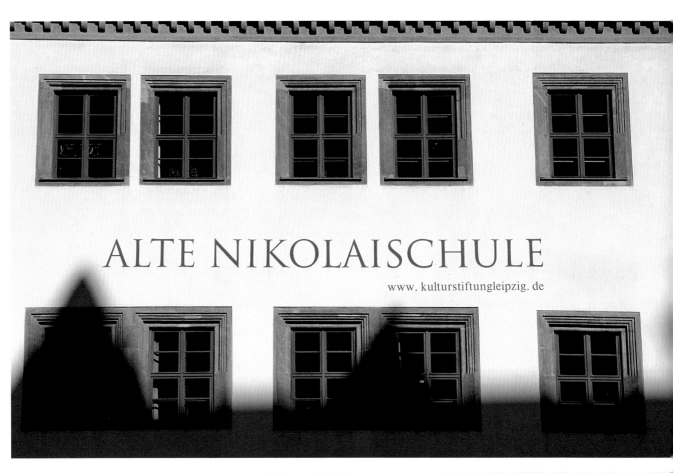

ALTE NIKOLAISCHULE

www. kulturstiftungleipzig. de

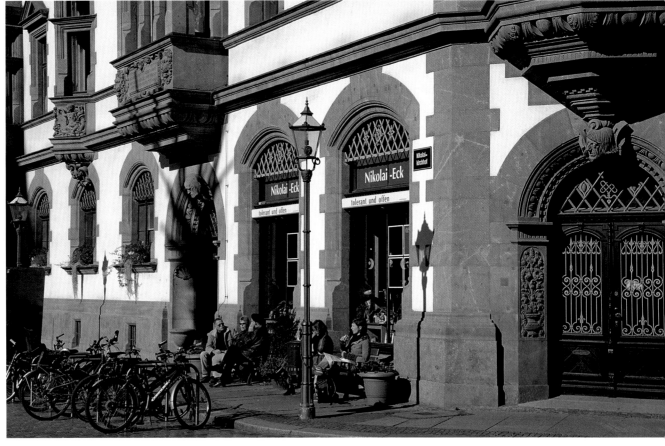

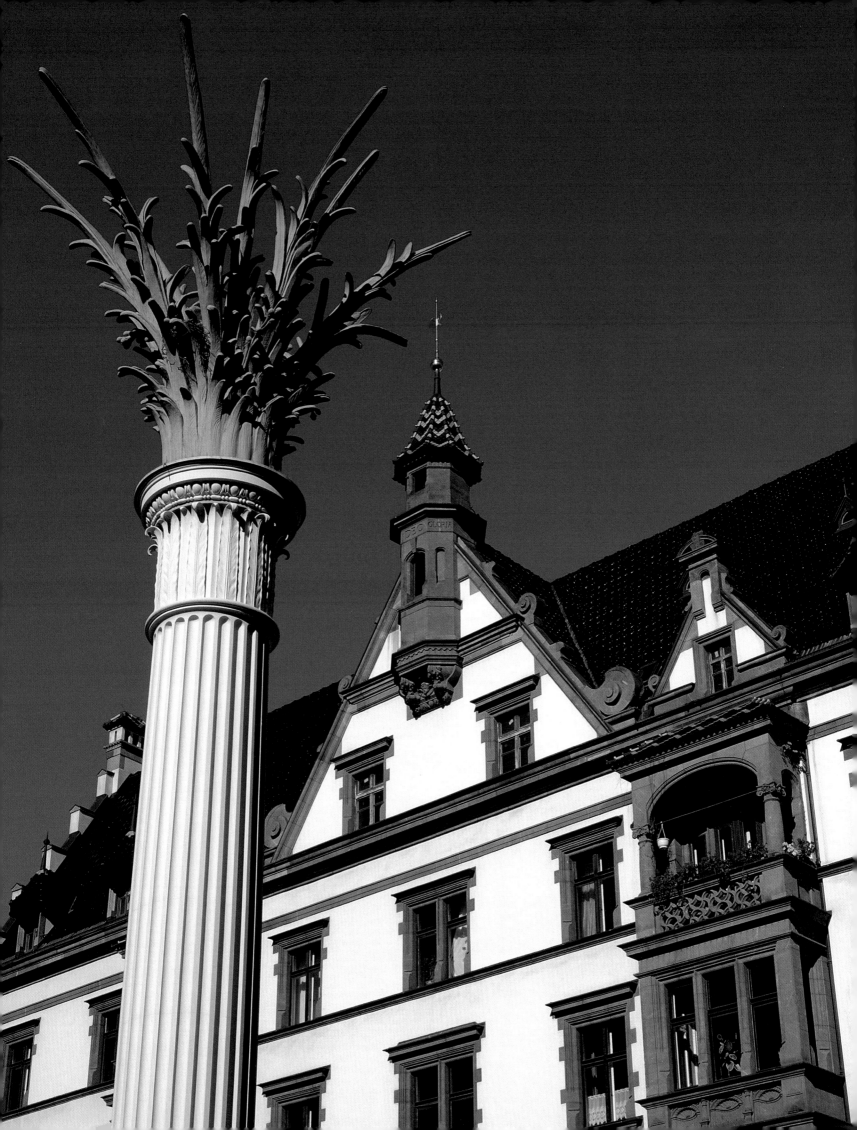

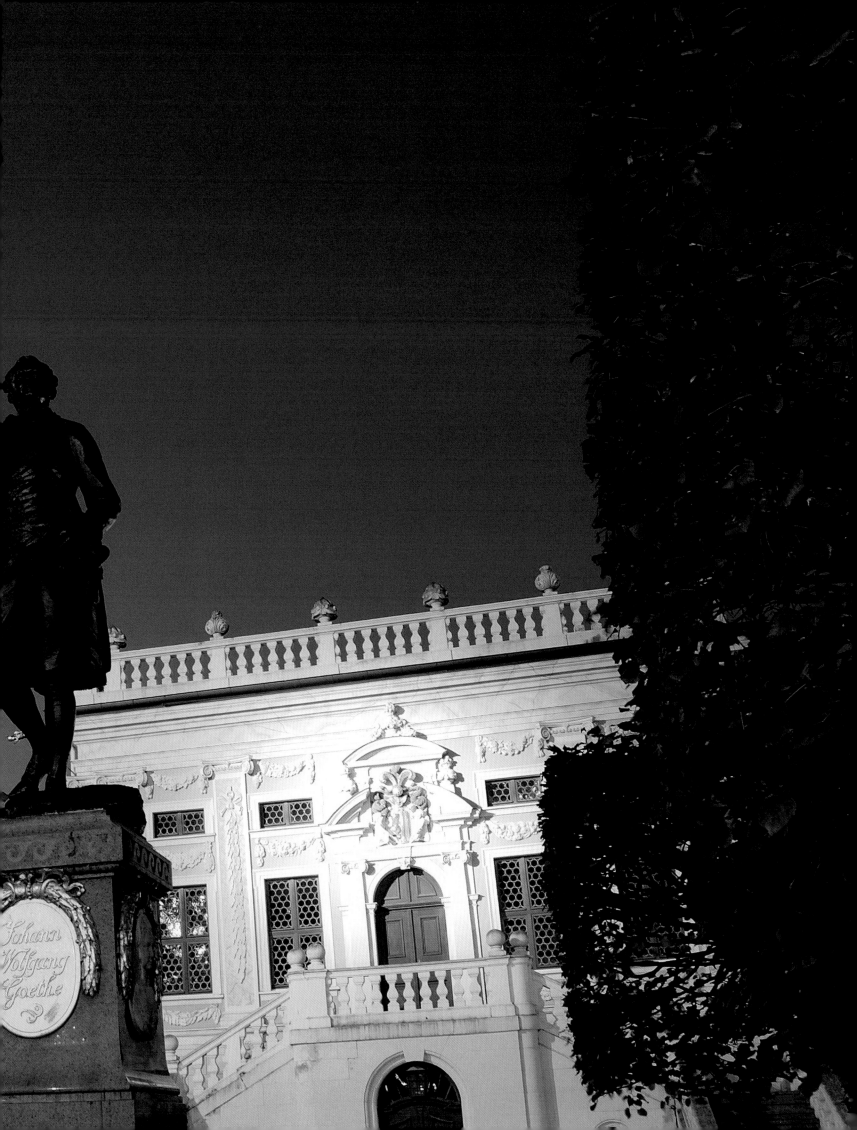

Right:
Building on the stock exchange was begun in 1678. It went into service the following year; the rich ornamentation of the facade and the elaborate interior furnishings were not completed until eight years later. The city emblem above the entrance underlines just how important the exchange was for Leipzig.

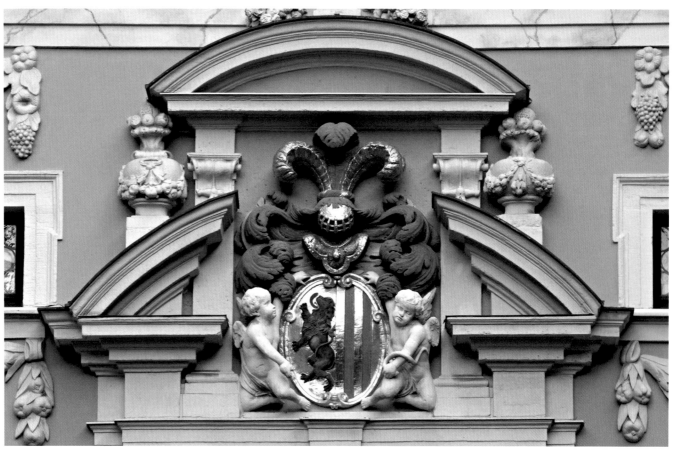

Right and far right:
The stock exchange suffered greatly during the war; the stucco ceiling is lost and many other details are now just replicas, such as the statues on the roof and the wrought iron gates.

Right page:
The intimate and scenic Naschmarkt is popular amongst locals and visitors alike.

BOOKS AND MUSIC –
CREATIVE LEIPZIG

During the 19th century rivals respectfully and rather enviously referred to Leipzig as the "city of books". Books were printed elsewhere, often in much larger quantities, but nowhere else were there so many businesses devoted to the cult product of the book in one place. There were enormous printing houses with special apparatus for the reproduction of musical notation, maps, foreign texts and postage stamps; there were giant book binderies, manufacturers of printing ink and engineering works; apprentices were trained for all branches of the trade – and to boot Leipzig was also the capital of the bookseller. Nowhere else were so many books sold as in Leipzig. This was the chief argument of the Börsenverein der deutschen Buchhändler zu Leipzig (German publishers and booksellers association), to whom their colleagues in Austria and Switzerland also belonged, when it came to deciding on the headquarters of the Deutsche Bücherei (German library) which since 1912 has collected everything written in German, regardless of which country it was printed in. Buchstadt (city of books) is thus a term which was readily applicable to a structured, major branch of industry in Leipzig.

The appellation of Musikstadt or city of music not only sounds more harmonious; it's also much more universal. Music is something which is part and parcel of public life in all fields, the epitome of representation and prestige. Leipzig's oldest cultural institution is thus also a musical one. At their monastery of St Thomas's founded in 1212 Augustinian canons once taught and cared for needy children, in return for which they were expected to enliven church services and other religious occasions with their singing. This bunch of waifs and strays, their requirements for admission often totally at odds with their musical prowess (or lack of it), has since grown into the famous boys' choir of St Thomas's, the Thomanerchor, whose history positively gleams through the work and music of one Johann Sebastian Bach. There's not enough space in this book to do full justice to his prolific and highly qualitative oeuvre; for some time now Leipzig, however, is honestly striving to sell itself as the city of Bach. The absolute climax of Bach worship, the Bach-Feste which have made the composer a permanent fixture on Leipzig's contemporary calendar of events, is not the only homage. With weekly performances of motets, cantatas, passions and organ music Bach is practically a daily feature in the round of musical happenings in Leipzig. Even if the Nikolaikirche was his main place of work, the Thomaskirche is the venue most strongly associated with the creative genius of JSB. Not far from it are the Bach Archives, the Bach Museum and the two Bach monuments. The oldest of the two was the first memorial to Bach ever to be erected, initiated and energetically supported by Felix Mendelssohn Bartholdy in 1843. In the same year his conservatoire, also the first of its kind in Germany, began coaching musicians.

The Leipzig Gewandhaus

In 1781 a festive concert hall had been installed on a floor of the municipal storehouse and textiles hall, the Leipzig Gewandhaus. Under Mendelssohn's directorship from 1835 to 1847 (bar one short break) the orchestra named after the Gewandhaus rose to international fame.

Later Kapellmeister of the Gewandhaus Kurt Masur held the esteemed post for 26 years, doing much more for Leipzig than 'just' conducting its traditional programme of music. It was he who fought the heads of the GDR for the construction of a new, third concert hall, representing Leipzig during his period of office like a world diplomat and on that memorable October 9, 1989, successfully calling for peace in a carefully worded speech transmitted via state radio. The fact that a museum was set up in the house once inhabited by his predecessor Mendelssohn is also to Masur's credit.

Other greats of Leipzig's music history include Richard Wagner, even if his native city was not particularly well disposed towards him. Robert Schumann and the Davidsbündler (League of David) are commemorated at their local, the Arabischer Coffe Baum, and for many years Clara Schumann quietly advertised her home town as the lady in blue featured on the hundred Deutschmark note.

The representatives of the world of light entertainment have had a slightly harder time of it. Albert Lortzing, who composed his wonderfully comic opera entitled *Zar und Zimmermann* (Tsar and carpenter) in Leipzig in 1837, is infamous in that absolutely nothing marks his presence here. The celebrated stars of the 1950s and 1960s – who include Kurt Henkels, Fips Fleischer and Fred Frohberg – have also faded into obscurity here. By way of contrast the landlord of the Zill's Tunnel pub has erected a veritable monument to Carl Friedrich Zöllner, he of the folk song *Das Wandern ist des Müllers Lust*. The annals of music history have also been slightly kinder to one of the "martyrs of beat music in the GDR", Klaus Renft; in 2007 a street was named after him in the suburb of Möckern ...

Left:
The first memorial to Bach was erected in 1843 on the initiative of Felix Mendelssohn Bartholdy.

Above:
It's hard to escape Bach in Leipzig. Not only do his eyes follow you around from the top of his monument (here

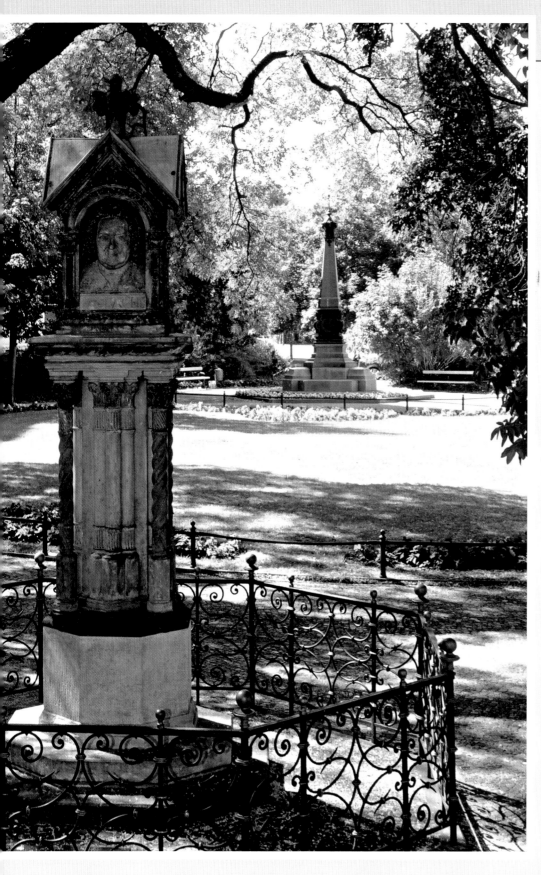

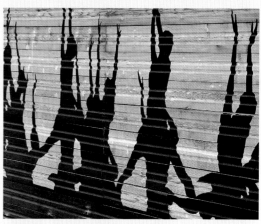

outside St Thomas's), but also from posters, leaflets, chocolate boxes and wine labels – to name but a few of the fan articles.

Top right:
The Grassi Museum is not one but three, containing the museums of applied arts, ethnology and musical instruments.

Centre right:
The artistic of Leipzig let no opportunity rest when it comes to spontaneous shows of creativity. In 2007 this shadow play used the construction site fences outside the opera house as a makeshift backdrop.

Right:
Good art and good paintings are the prerequisites of a successful artist – and as in this example a modest yet pleasant setting is often quite sufficient.

Galerie EIGEN + ART

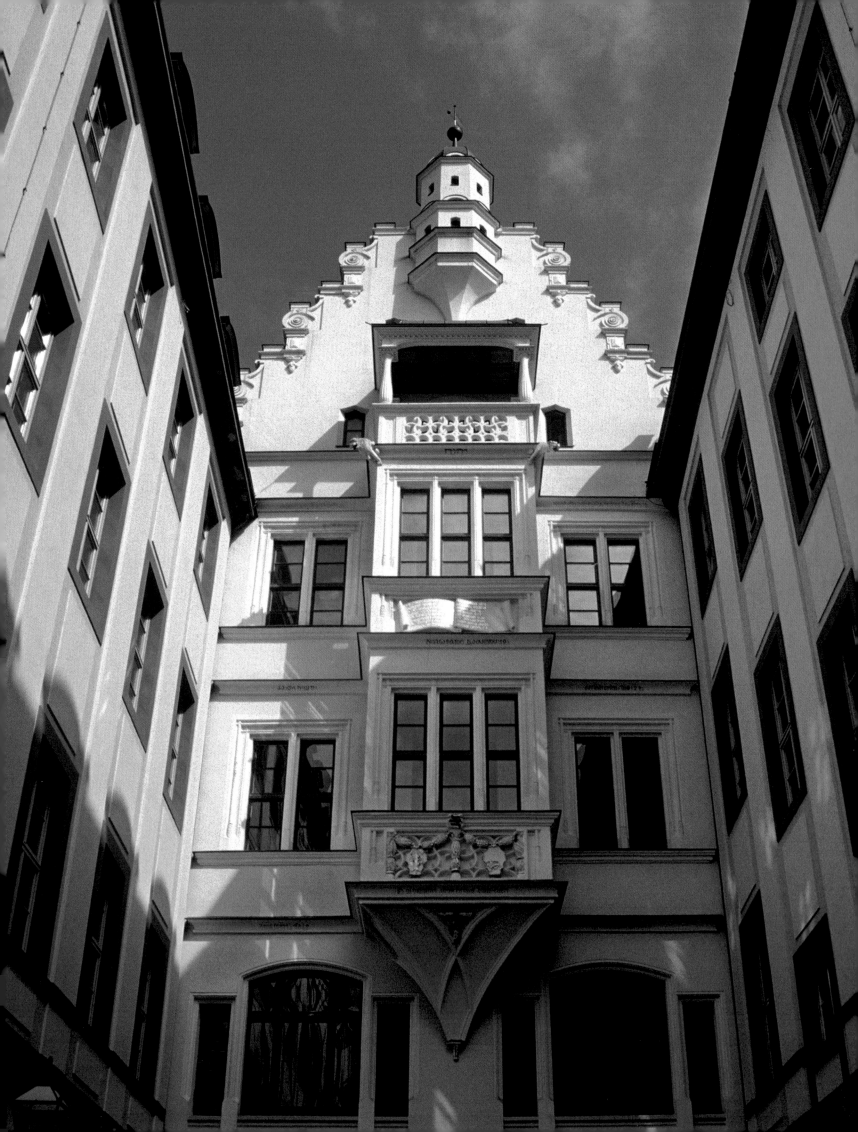

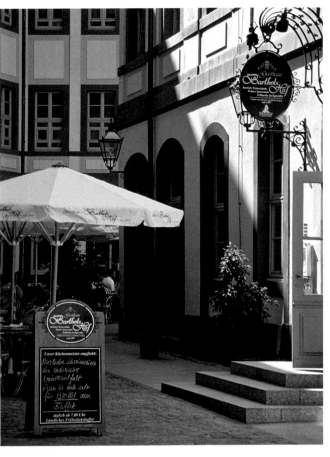

Left page:
The only merchandising house or "half-city", as Goethe called them, still standing in Leipzig is the Zur goldenen Schlange or Barthels Hof. Situated on the market place the former branch of Wels Bank from Augsburg is without a doubt one of the city's architectural gems.

Left and far left:
The crane girders on the courtyard side of the attic attest to the building's original purpose. The complex has long been put to a different use, however; travellers have been fed and watered here since 1890, for example, and in the basement an off-scene theatre recently set up shop.

Left:
The courtyard exits onto a square featuring a fountain of Lipsia between Barfußgasse and Kleine Fleischergasse, now part of Leipzig's humming pub scene. If you fancy an authentic night out on the town, just ask for directions to "Drallewatsch". Cheers!

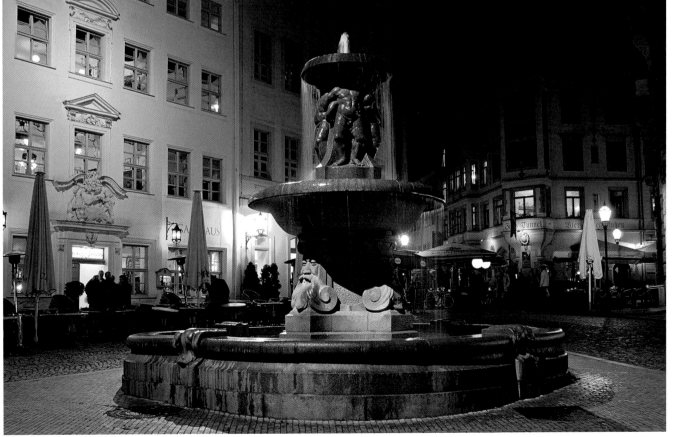

69

Above:

Up until the 1930s Nikolai-straße and Brühl were the hub of the international fur trade. Today there are but few reminders of this lost tradition. The naked cherubs on the former fur emporium, for example, still demonstrate the many elegant uses for wares purchased from the furrier.

Right:

Some of the names emblazoned above the old fur salesrooms are so permanent that they alone have managed to survive the passage of time. The Selter & Weiner building, for example, is named after the imperial Japanese consul Alfred Selter.

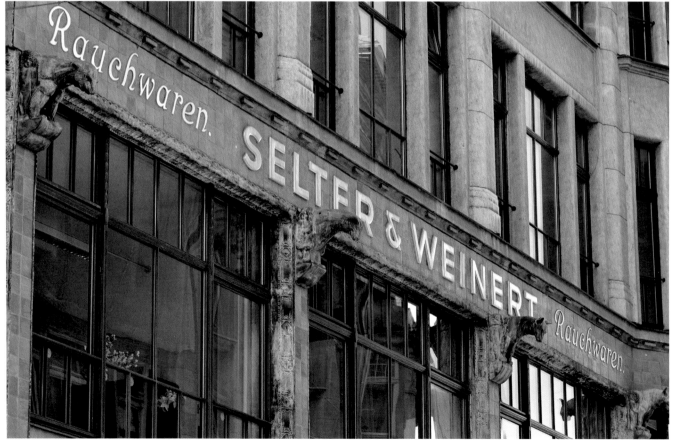

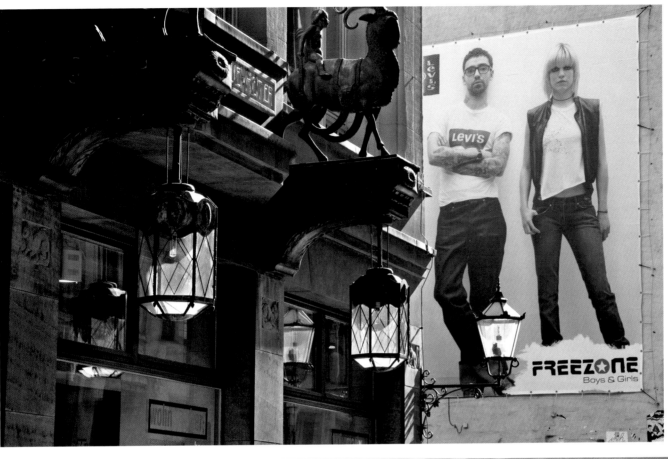

Left:
The name of this house (Zwei Reiter or two riders) doesn't appear in any of the old city records. Giving your abode an official nomenclature is a custom which was long upheld in Leipzig, as this example demonstrates.

Below:
The Zeppelin-Haus built in 1911 is named after the inventor of the airship, Count Ferdinand von Zeppelin, which in 1909 was first seen gliding over the rooftops of Leipzig. The council brewery stood on this site from 1685 to 1821.

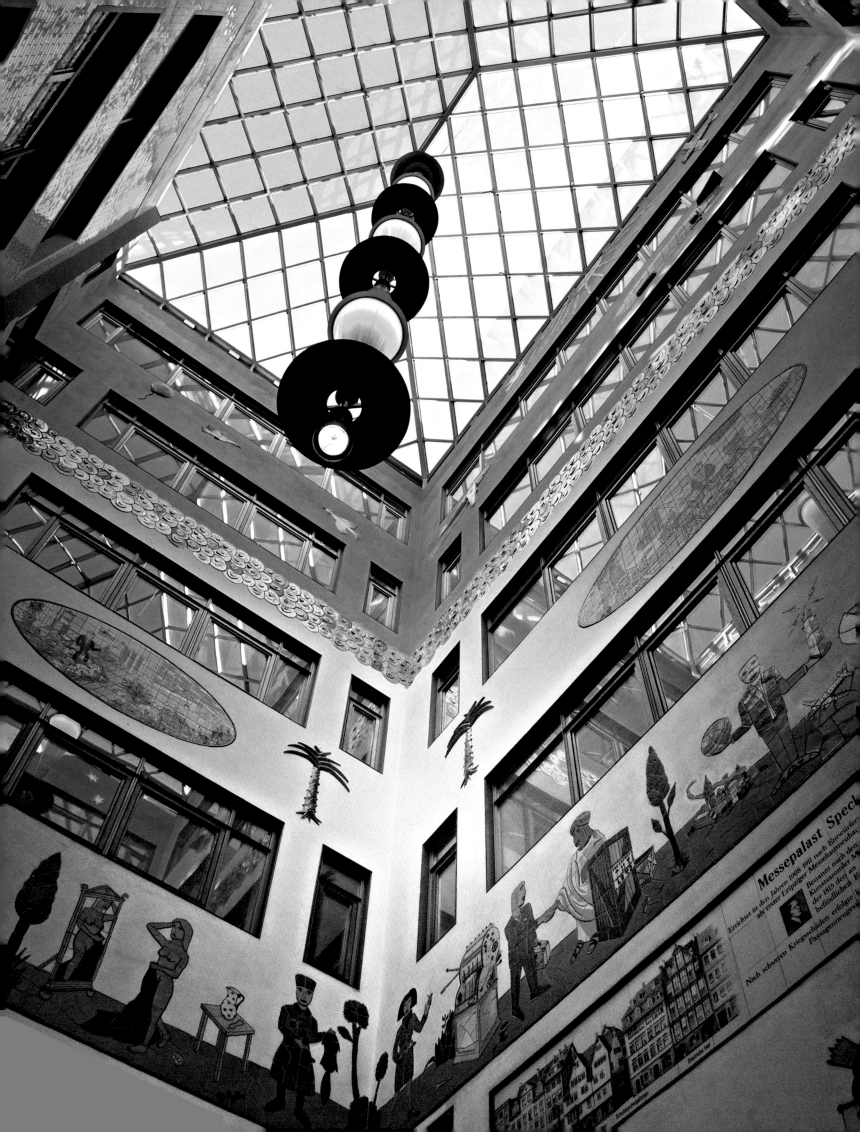

Messepalast Spech

Errichtet in den Jahren 1908-1911 nach Entwürfen
als erster Leipziger Messehaus

Benannt nach der
Kunstsammler N
der 1815 den an
befindlichen M

Nach schweren Kriegsschäden erfolgte
Passagenneuges

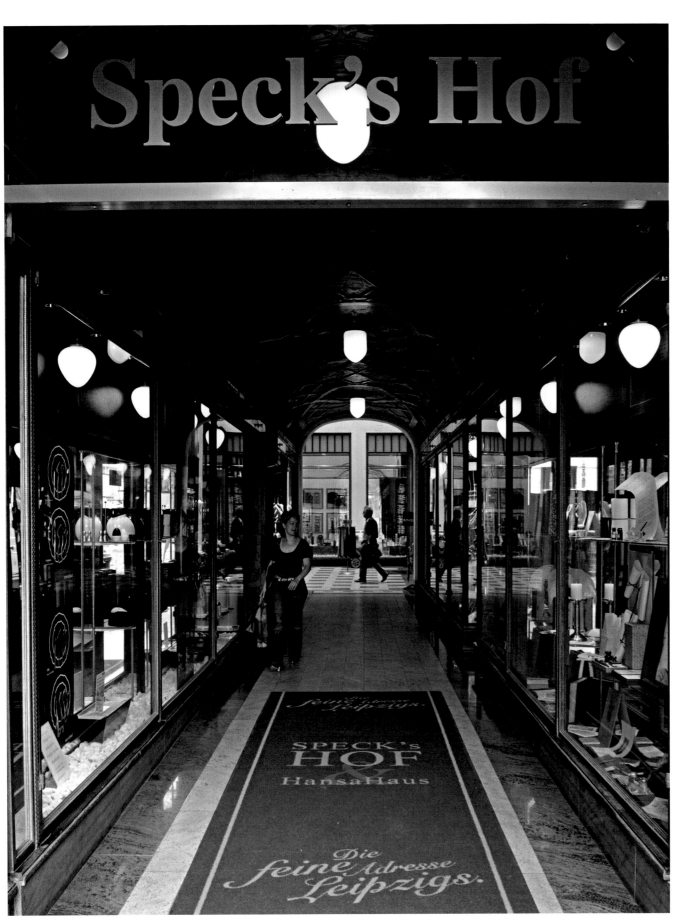

Left page:
The trade hall Specks Hof, built in three stages at the beginning of the 20th century, was refurbished in the 1990s. Leipzig artist Moritz Götze's ceramic pictures portray the times of day.

Left:
Bits of the original decor of the Specks Hof arcade are still visible.

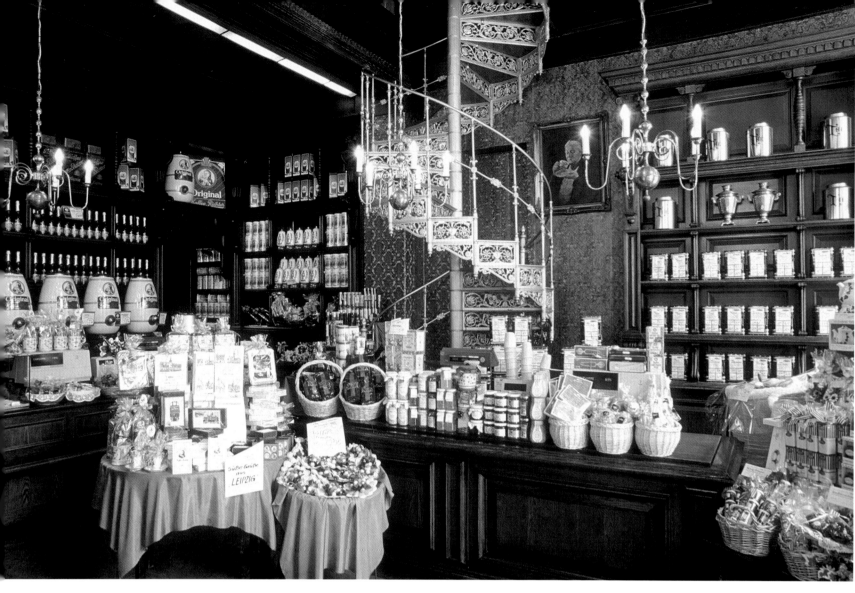

Above:

The Max Richter coffee emporium, founded in 1879, was built in the 1880s in the same neo-Renaissance style as the former imperial bank next door. Its tasteful interior dates back to the days of the German Kaiser.

Right:

One of the largest trade halls in town was the Petershof from 1927/28 which also housed the biggest cinema in Leipzig, the Capitol. The facade is embellished by seven statues symbolising the occupations and people crucial to the success of the trade fair in the 1920s.

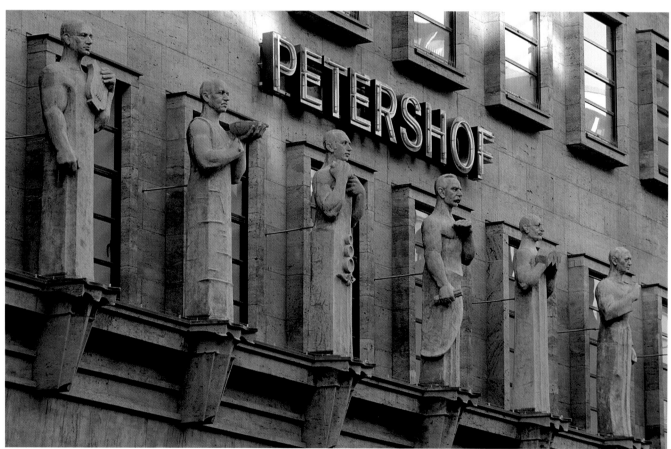

Above:
Unusual in its bright colouring, the Klingerhaus on Petersstraße is a real eye-catcher. The neo-Renaissance facade was created in 1887/88. The man who had it built was the father of the renowned painter, sculptor and graphic artist Max Klinger.

Left:
Petersstraße was the main thoroughfare which serviced the historic centres of trade in Leipzig. In the 16th and 17th centuries each house on the street was equipped for sale and purchase. In 1912–14 the Althoff store was added to the street (left) which from 1920–1948 and since 1990 has belonged to Karstadt, a major German concern.

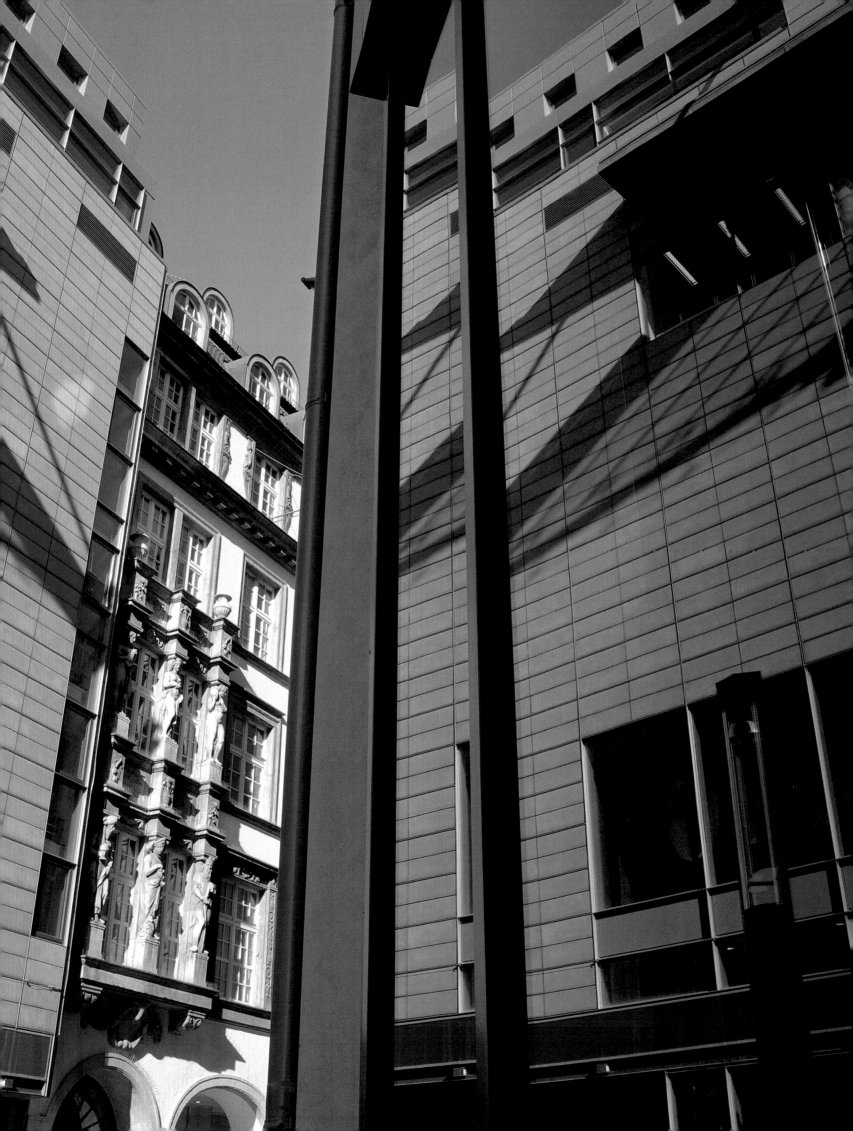

Left page:
This reflection in the Karstadt facade makes the Drei Könige building seem very narrow. The latter was built as a trade hall for shoes on the site of a pub of the same name in 1915/16. One of the rooms was where August Bebels, founder of the German Social Democratic Party (SPD), had his woodturner's workshop.

Below:
The inscription on the gable of the old trade hall Stenzlers Hof on Peters-straße is proof that Leipzig continued to build even in times of economic strife – such as during the First World War.

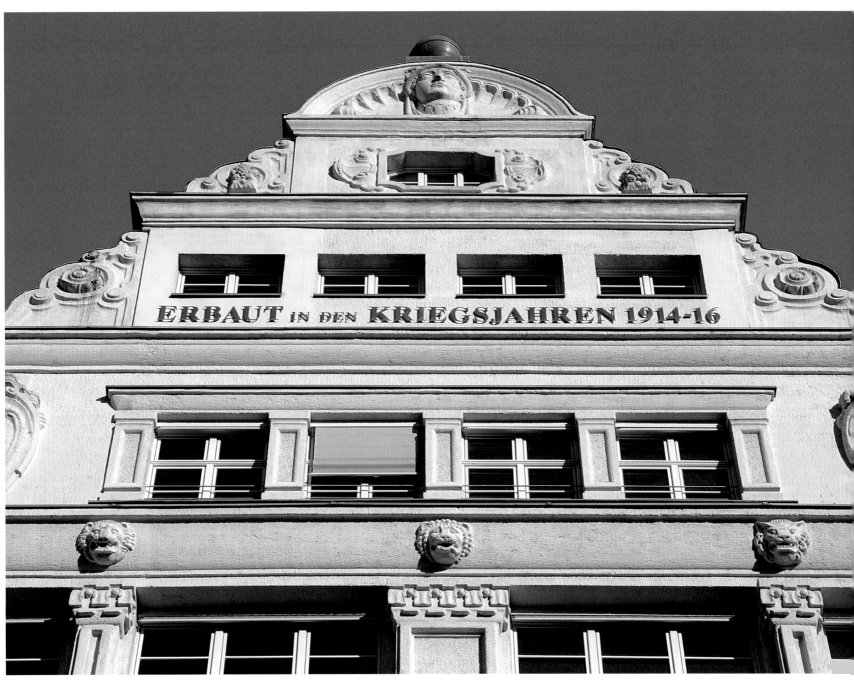

ERBAUT IN DEN KRIEGSJAHREN 1914-16

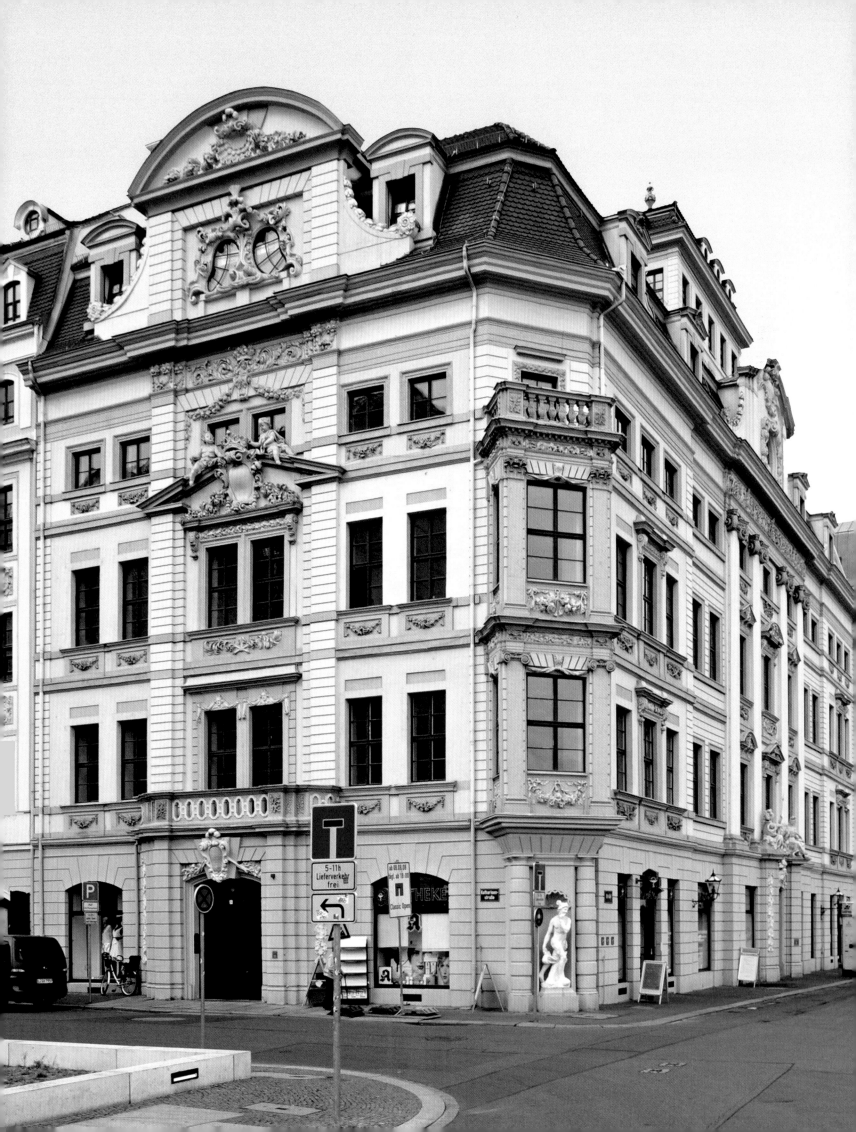

Left page and left:
One of the jewels of baroque architecture in Leipzig is the Romanus-haus, named after its creator Franz Conrad Romanus. Just 30 years of age, the young upstart from Dresden was made mayor of Leipzig by Augustus the Strong. In order to evoke a modicum of respect from his subjects he had this showy residence erected in 1701–04, introduced street lighting in time for Christmas in 1701, had the promenade planted up and the first sewers installed. Nothing helped. When it emerged that he had built his house with money taken from the city coffers, his patron had him arrested and incarcerated in the fortress of Königsstein without trial for 41 years – until his death. Today the painstakingly restored facade gives us a good impression of what glories Saxony must have feasted upon during the early 18th century. Sadly, the valuable interior decor was totally destroyed in the course of a brutal 'restoration' project carried out in 1965–69.

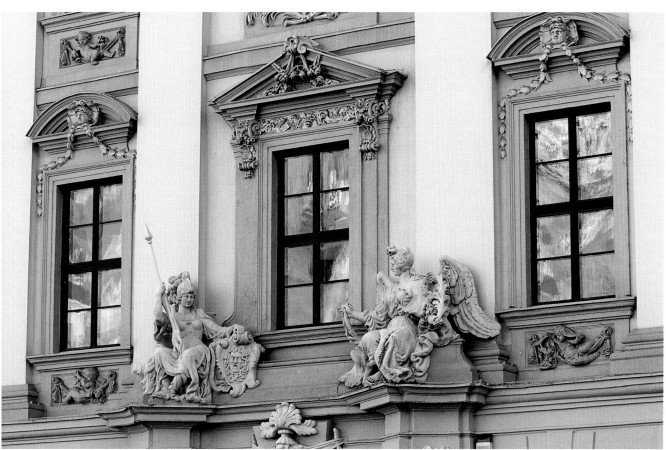

Right and below:
The old Frege Bank, where Goethe also held an account, boasts a typical Leipzig courtyard simply bursting with colourful blooms in the summer.

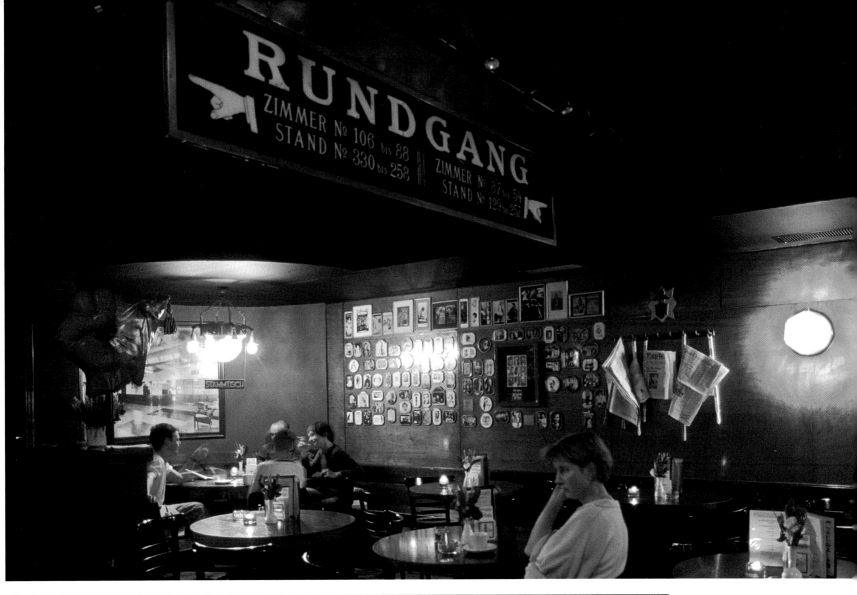

Above:
In the 1970s the now nationally famous cabaret academixer set itself up in wonderful Art Deco surroundings in the basement of the old Dresdner Hof trade hall. The theatre includes a homely pub frequented by local artists and artistes.

Left:
With its surreal figurines the entrance to academixer is 100% Pop Art.

COFFEE, *GOSE* AND *ALLERLEI* – CULINARY LEIPZIG

Saxony is the oldest coffee state in Germany and Leipzig the capital of coffee – and with good reason. The story goes as follows. In 1683 a regiment of Saxons found themselves caught up in the Battle of Kahlenberg, in which the Turks were beaten back from the outskirts of Vienna. The hurriedly abandoned Turkish camp was littered with booty which the victors duly plundered and pillaged. Sackloads of strange green beans found their way back to Saxony on the back of a 17th-century lorry. Prior to their departure a dubious but well-informed Viennese local had told the Saxons how to turn these strange pods into a weird and wonderful beverage. The brew was tentatively prepared back home and once they had got used to the taste the Saxons were hooked. In 1719 the first coffee house in Saxony opened in Leipzig. Its name, Zum Arabischen Coffe Baum or Arabic coffee tree, was derived from the exotic plant which just happened to be growing in a Leipzig garden at the time. Coffee quickly became a 'democratic' drink, being consumed in equal amounts by people of all ranks and classes. It was so popular that even the great Johann Sebastian Bach wrote a piece of witty music in its honour, the famous *Coffee Cantata* (BWV 211). The Coffe Baum is now a restaurant and interesting museum in which you can learn not just about the history of coffee but also savour java specialities from all over the world.

With your latte or cappuccino in front of you, all that's missing is a typical Leipzig pastry – the history of which is no less bloodthirsty. Since the 17th century, as in France songbirds had been served as a delicate hors d'oeuvre. In August 1860 the region was hit by a violent hail storm in which thousands of birds perished, including many larches. Conservationists subsequently began petitioning for the protection of animals and in 1876 King Albert finally banned the hunting of larches by law. *Leipziger Lerche* (Leipzig larch) had proved such a successful trademark, however, that local chefs were unwilling to relinquish it. It was the pastry cooks who saved the day; instead of stuffing real birds they filled short crust pastry cases with marzipan and popped a black cherry on top for the larch's heart. The roast bird's legs had been tied diagonally through the eye sockets to stop the bird disintegrating during cooking; in emulation the wily bakers placed two strips of pastry over the filling. This method of preparation is still used today and *Leipziger Lerche* is now a tasty, totally vegetarian and politically correct delicacy!

Eierschecke and *Quarkkäulchen*

The Saxons are not only heralded as gourmets for their (formerly) avid ingestion of songbirds. Although something of a Dresden speciality, *Eierschecke* is also native to Leipzig. Made of egg yolk, butter, sugar, quark, sultanas and custard, the lighter the pudding, the higher the mixture rises in the oven – and the greater the praise for the cook. *Quarkkäulchen* are dough balls made of quark, grated boiled potatoes, eggs, sultanas and flour which are fried in a pan and served piping hot and dusted in sugar and cinnamon. Although tradition dates them back to a wine tavern from 1525, one particularly delicious variety is served at Auerbachs Keller. Here you can also tuck into a plate of good, hearty Saxon-Thuringian fare – with maybe a slice of *Mephisto Torte* (hazelnut biscuit, orange marmalade and almond marzipan) for afters. Delicious!
Gose is a different matter entirely. It's a top-fermented wheat beer which has been supped in Leipzig since the mid 18th century. The fine lactic acid generated during the brewing process is seasoned by adding cooking salt and coriander. The brew is then perfected by adding a glass of caraway liqueur (for men) or cherry liqueur (for women). Bar a forced intermission imposed by the authorities of the GDR the microbrew has been served in the special *Gose* pub Ohne Bedenken in Leipzig-Gohlis since 1899. The Bayrischer Bahnhof now also sells it – brewed by an enterprising Bavarian who has set up shop in Leipzig.
No list of Leipzig specialities would be complete without *Leipziger Allerlei*. The name can often be found printed on tins of processed vegetables – but as any Leipziger will tell you, this has absolutely nothing to do with the original dish. *Allerlei* means variety – and as opposed to the uniform and rather tasteless chunks in the cans this is what you get, at least in Leipzig. Petits pois, carrots, kohlrabi, cauliflower and white asparagus bought fresh from the market are fried in butter in separate pots. The morel mushrooms added for flavour used to be picked in the neighbouring Auewald and the crayfish placed on the top for decoration caught from the mill stream running past your front door. The vegetable dish is a time-consuming but colourful accompaniment to pork chops or fish. In an age where slow, wholesome food is successfully combating the faster, unhealthier varieties, *Leipziger Allerei* definitely has a future.

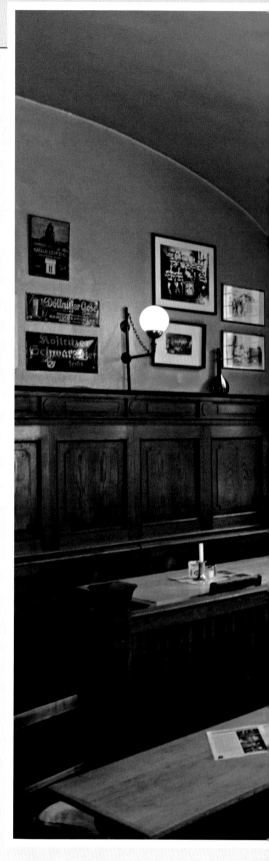

Left:
The first cup of coffee served in Leipzig is duly honoured in that it features above the entrance of the coffee house Zum Arabischen Coffe Baum.

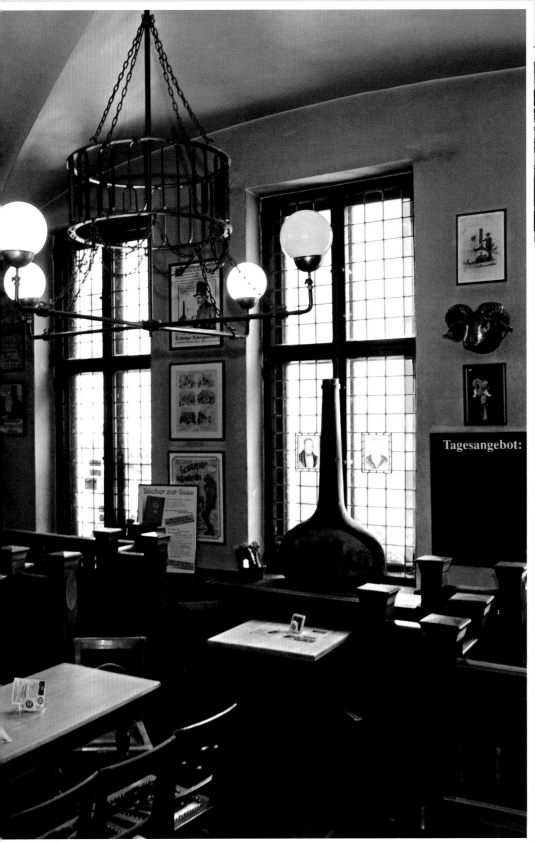

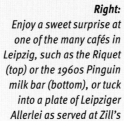

Above:
For over 100 years the
Ohne Bedenken pub,
truly original in all senses
of the word, has sold
Leipzig's top-fermented
Gose wheat beer.

Right:
Enjoy a sweet surprise at
one of the many cafés in
Leipzig, such as the Riquet
(top) or the 1960s Pinguin
milk bar (bottom), or tuck
into a plate of Leipziger
Allerlei as served at Zill's
Tunnel (centre).

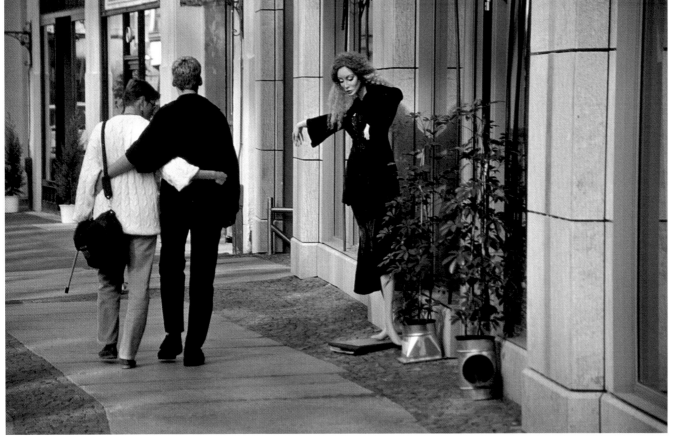

Above:
The Jägerhof between Hainstraße and Große Fleischergasse has three courtyards. The name of the trade hall has nothing to do with hunting, as the word "Jägerhof" or "hunter's place" would suggest, but is derived from the man who had it built, distinguished businessman Jäger.

Left:
There are plenty of interesting nooks and crannies to be discovered on a stroll through Leipzig.

Left page:
Coffee has been served at Zum Arabischen Coffe Baum since 1719, making it one of the oldest coffee houses in Europe. Composer Robert Schumann and his artist friends of the League of David met here regularly.

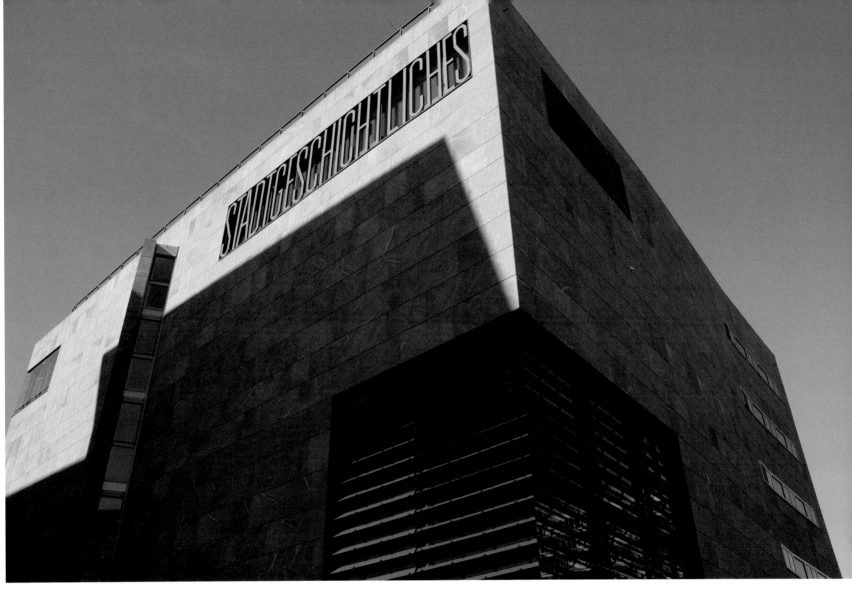

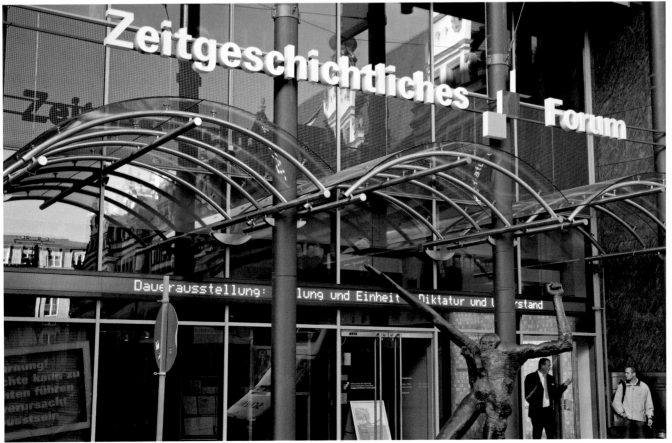

Above:
In the old town quarter between Katharinenstraße and Reichsstraße four further buildings are planned in addition to the new museum. A suitable abode for the museum of city history has already been constructed.

Left:
Wolfgang Mattheuer's sculpture "Jahrhundert-schritt" (step of the century) depicts the problems of the 20th century: dictatorship and departure, militancy and nakedness, disunity and panic. The artist's work was finished in 1985; its refusal to deny the truth was considered a provocation in the GDR.

"Beyond the gates" – the outskirts

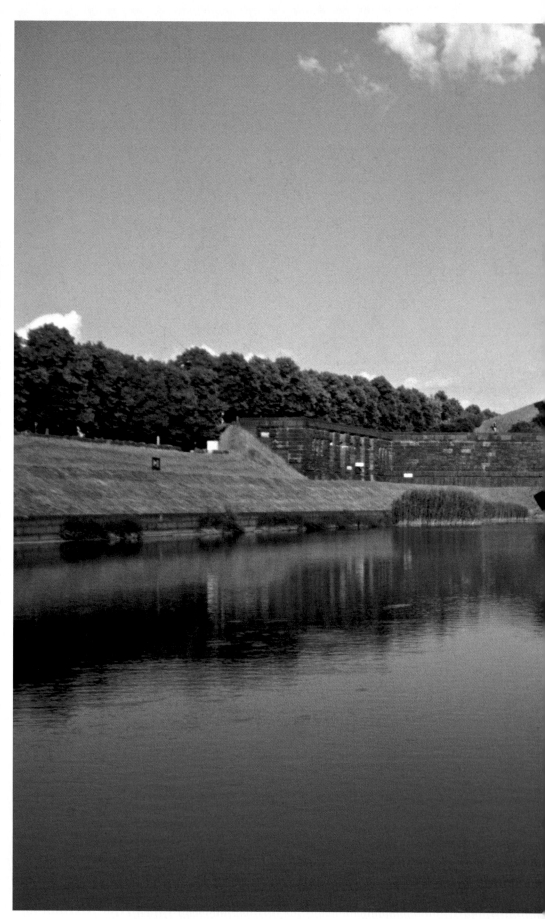

At 91 m (300 ft) tall and 3,000,000 metric tons in weight the monument to the Battle of the Nations is one of the biggest in the world. Despite the intention of the German Patriotic League that all 125,000 victims of the slaughter be commemorated, regardless of their nationality, the memorial has sadly been used as propaganda against other races on more than one occasion.

Like many other old towns, once upon a time Leipzig was surrounded by walls and ditches, with gates and arches allowing wagons and pedestrians to pass in and out of the city. Mighty bastions protected the town from the evil designs of would-be attackers. For centuries Leipzig was a city of stone, the restricted space within its defences far too precious to be wasted on the planting of large trees. Fruit grew on trellises up the south facades of some houses, some had a few vines and a few of the better off even had a tiny herb garden. Gardens used for growing vegetables or in which to take your leisure were banished outside the city gates. Reudnitzer Kohlgärten, for example, now just a street name, was where greens were cultivated which were sold at market.

In 1702/03 Mayor Franz Conrad Romanus had limes, chestnuts and mulberries planted outside the walls from the Barfußpförtchen to the Thomaskirche. The younger of his citizens in particular thought this ideal for their afternoon strolls and assignations, parading petticoats and parasols "ums Tor", as the path around the city confines was once called. A change of mood during the baroque period prompted the city to blossom in the full sense of the word, with around thirty gardens planted up against the walls at the beginning of the 18th century. Unlike the royal pleasure grounds of Germany's residential seats these private town gardens were generally open to all at all times. Much of Leipzig's free time was thus spent beyond the city gates.

With the exception of the bit of land now known as the Johannapark, all of these gardens have since disappeared. Just a handful of street names, such as Apels or Czermaks Garten, are left to remind us of the former horticultural splendour of Leipzig. The city is still green, however, with the Auewald on the Elster and Pleiße bravely hugging the outskirts of town. 2,500 hectares (ca. 6,180 acres) in size and riddled with streams and rivers, the woods are a popular sport and recreation ground.

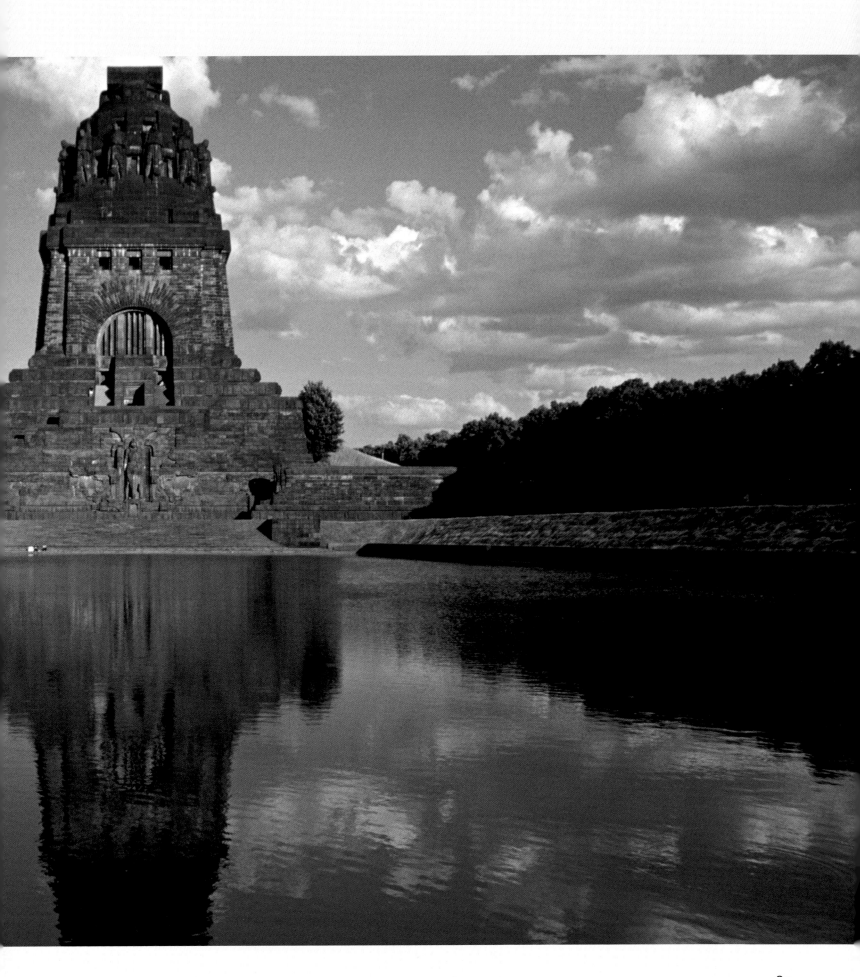

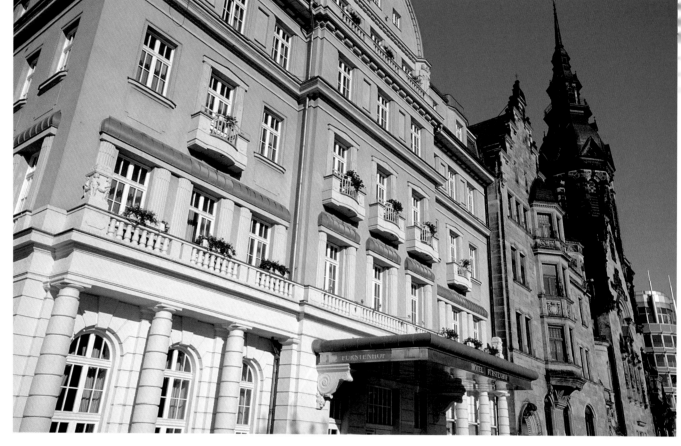

The Fürstenhof Hotel
is situated in an ancient
garden and since its
opening in 1913 has been
considered one of the top
establishments in town.
Its ballroom is one of its
prime features, elegantly
furbished in serpentine
stone from Saxony.

The main station was
also built during
Leipzig's golden age at
the beginning of the
20th century. No less
than 26 platforms
have serviced the rail
network since its grand
inauguration in 1915.
Following its revamping
in 1995–97 it's now also
a huge retail outlet.

Right page:
The Villers-Brunnen
from 1903 (foreground)
remembers the former
owner of Löhrs Garten,
the park where the huge
Ring-Messehaus from the
1920s still stands. Once
the biggest exhibition hall
in the world, the complex
is now sadly disused.

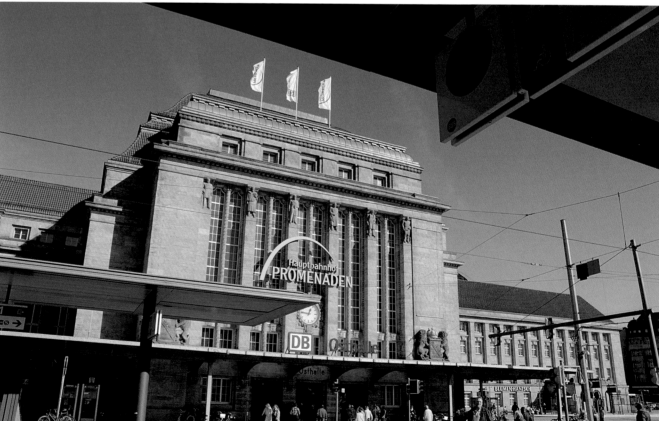

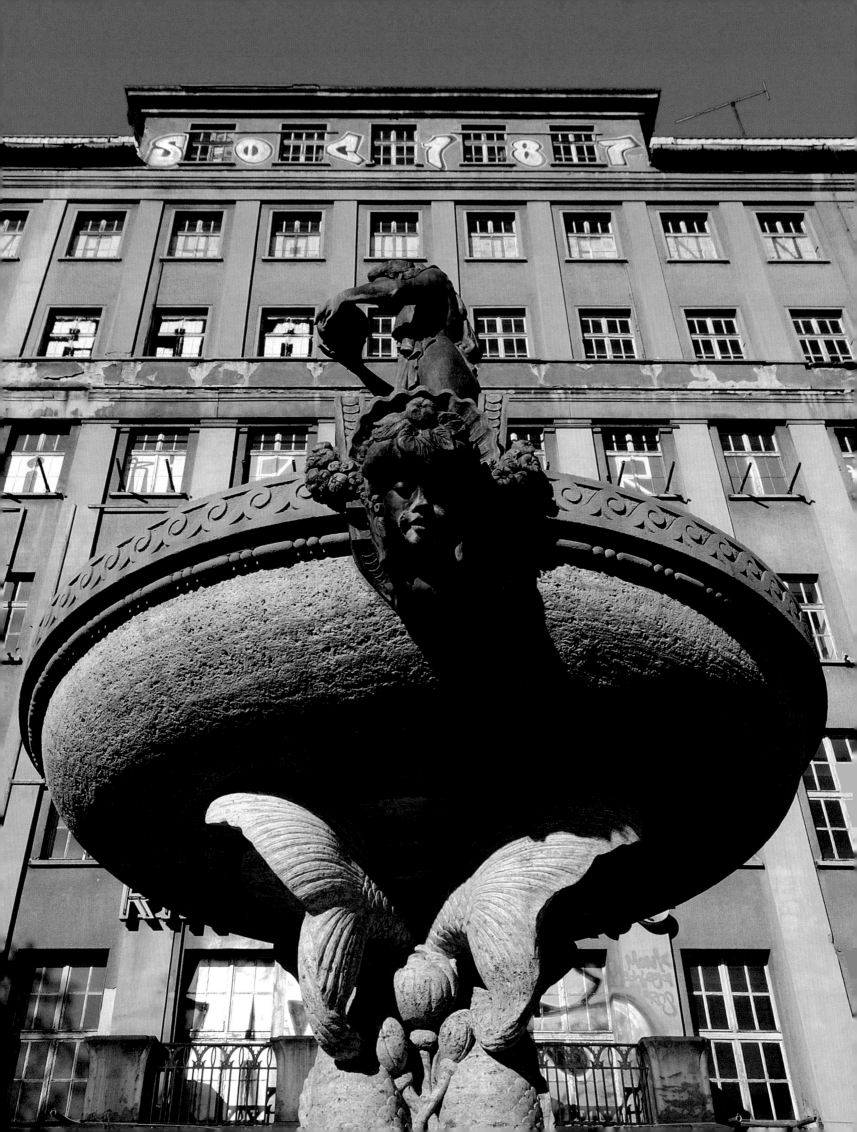

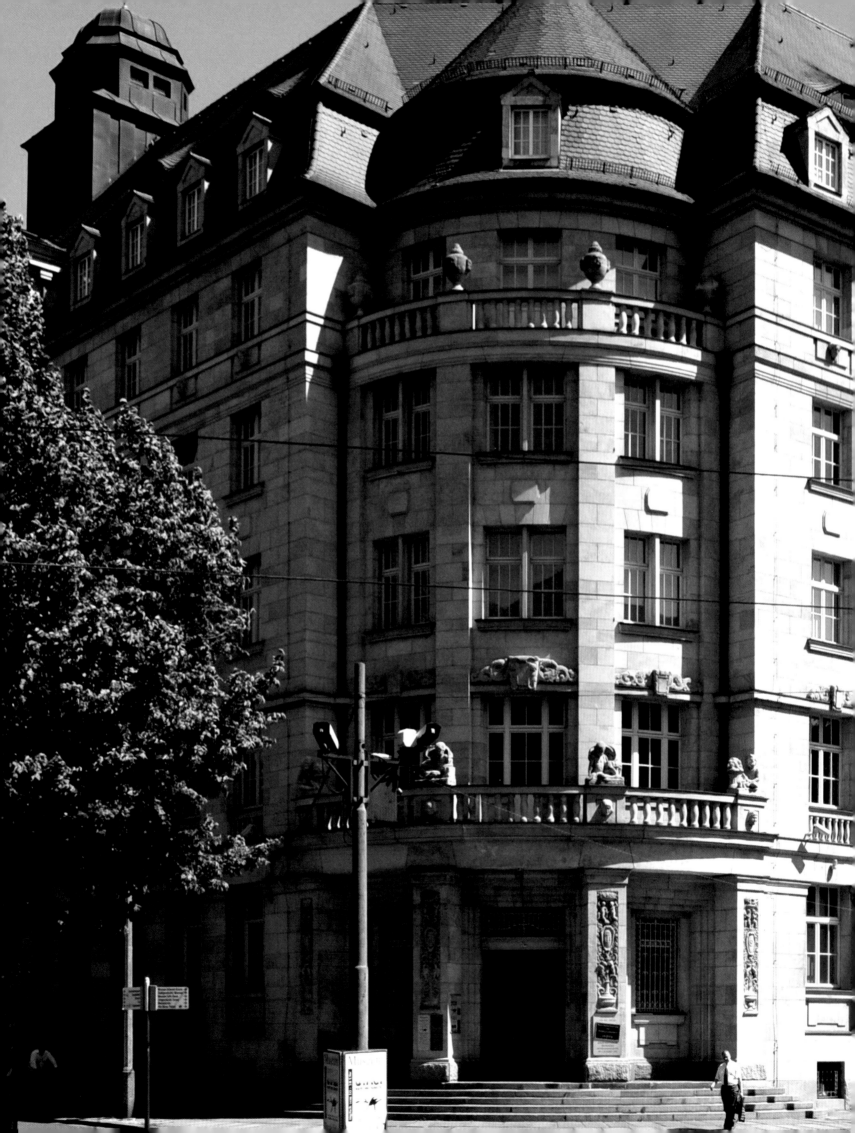

Left page:
The best known and most feared building on Dittrichring is on the corner where the Stasi had their headquarters during the GDR period. The architectural design gave rise to the people of Leipzig's code name for the building and the Stasi in general: "Runde Ecke" or round corner. The museum now housed within documents this shadowy period in Leipzig's history.

Photos, left:
The abundance of Historicism on Dittrichring underlines the popularity of this style at the turn of the 19th century, with plenty of pleasing details to be found.

Page 94/95:
Leipzig has long shaken off its dubious reputation as a city "on the water", largely brought about by the frequent flooding here. During the 1950s the town's rivers, polluted by stinking brown coal waste water, were banished underground and into pipes. A modern urban project is now intent on again exposing these waterways, such as here at the Lurgensteinsteg. The villa to the right of it has works of art owned by the bank Sparkasse Leipzig on display.

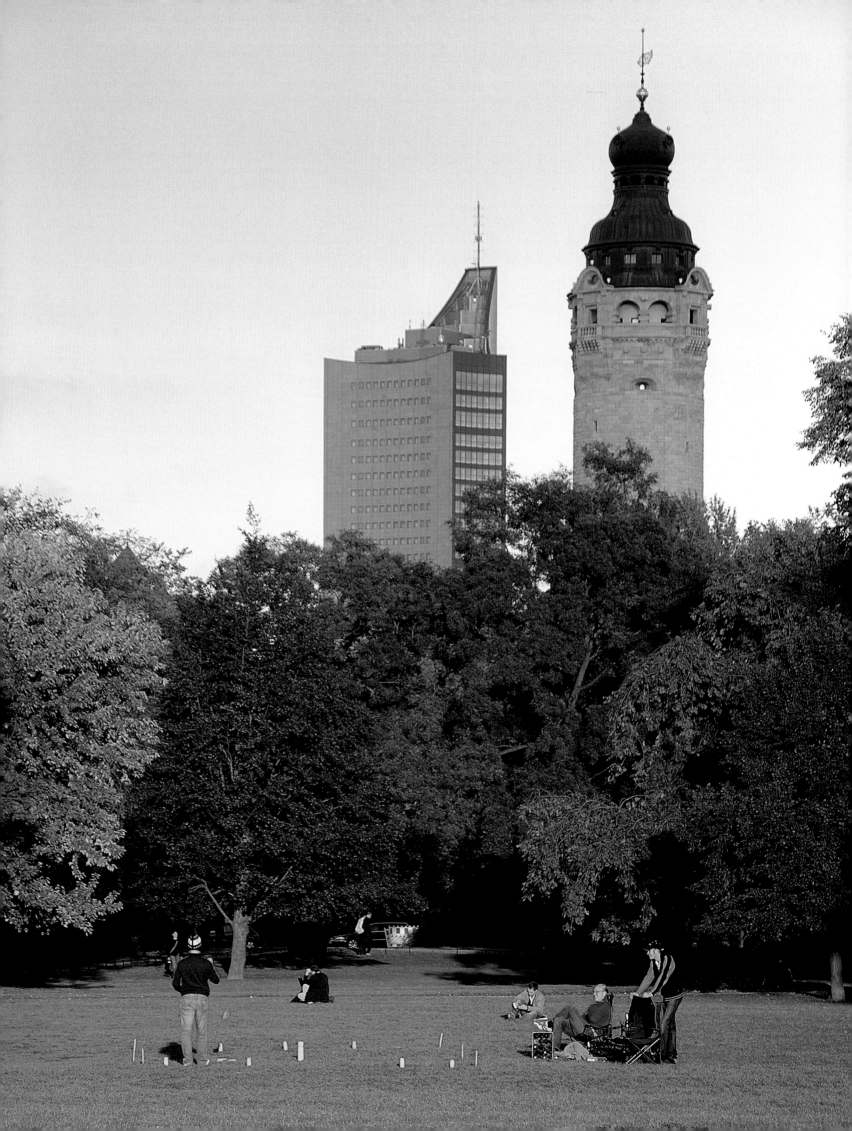

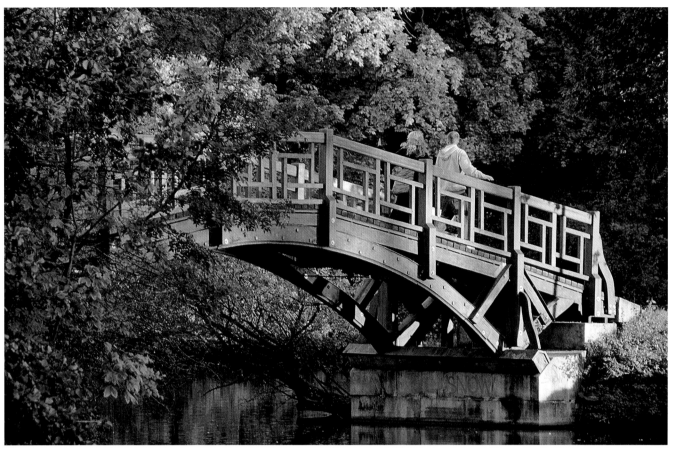

Left page and left:
The Leipziger hold the Johannapark very highly in their affections. Expansive meadows provide plenty of space for energetic play, gentle exercise and lazy sunbathing, with lots of ancient trees providing welcome shade on a hot day. A romantic wooden bridge smacks vaguely of Japan. The bust below depicts the man to whom all this is owed: banker Wilhelm Seyfferth, who was instrumental in the construction of the first railway. In 1881 he bequeathed his private garden-cum-park to the city, stipulating that it may never be built upon. To date the city has kept its promise.

Page 98/99:
On the founding of the German empire in 1871 Prussia and Bavaria just couldn't agree on which of the two countries the supreme court should hold session in. By way of compromise it was set up in Saxony. The imposing edifice built in 1888–95 is now the seat of the supreme administrative court of Germany. The reopened mill stream which runs alongside it, the Pleißmühlgraben, is called Mendelssohn-Ufer at this point in honour of the monument to the great musician which once stood here, destroyed by the Nazis in 1936.

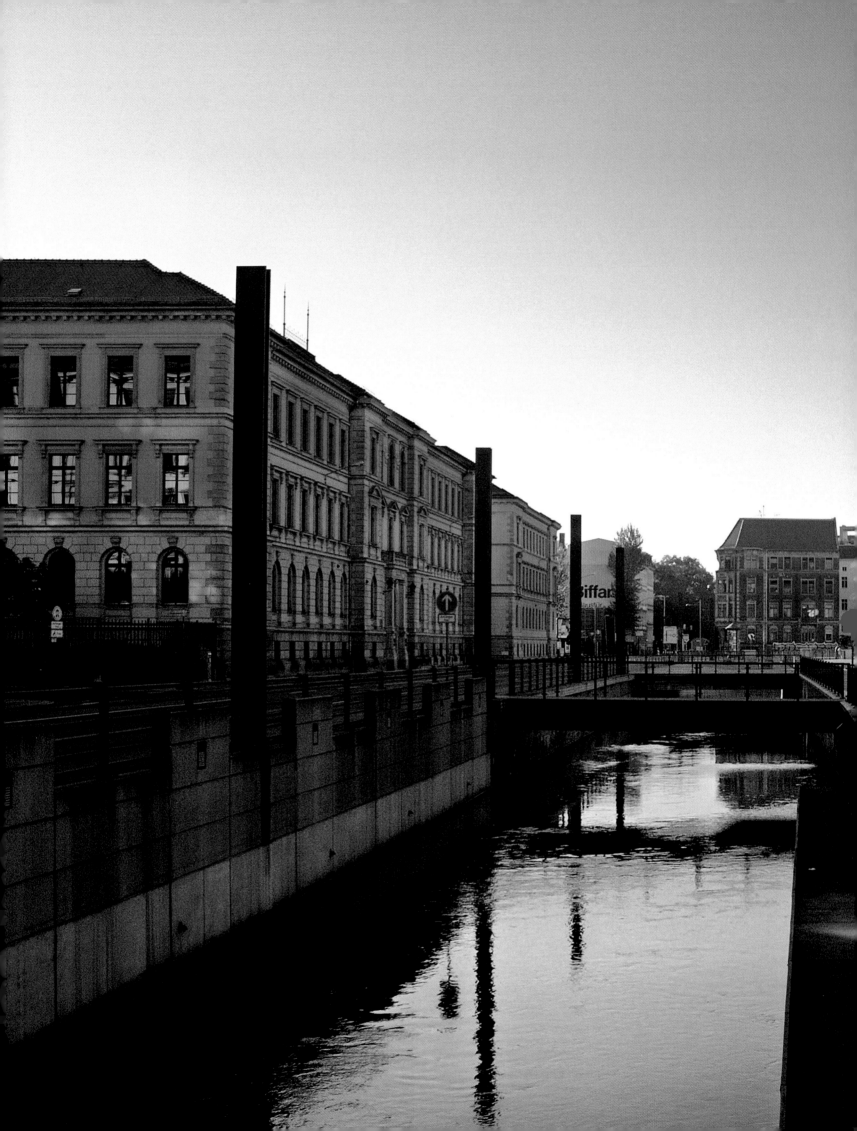

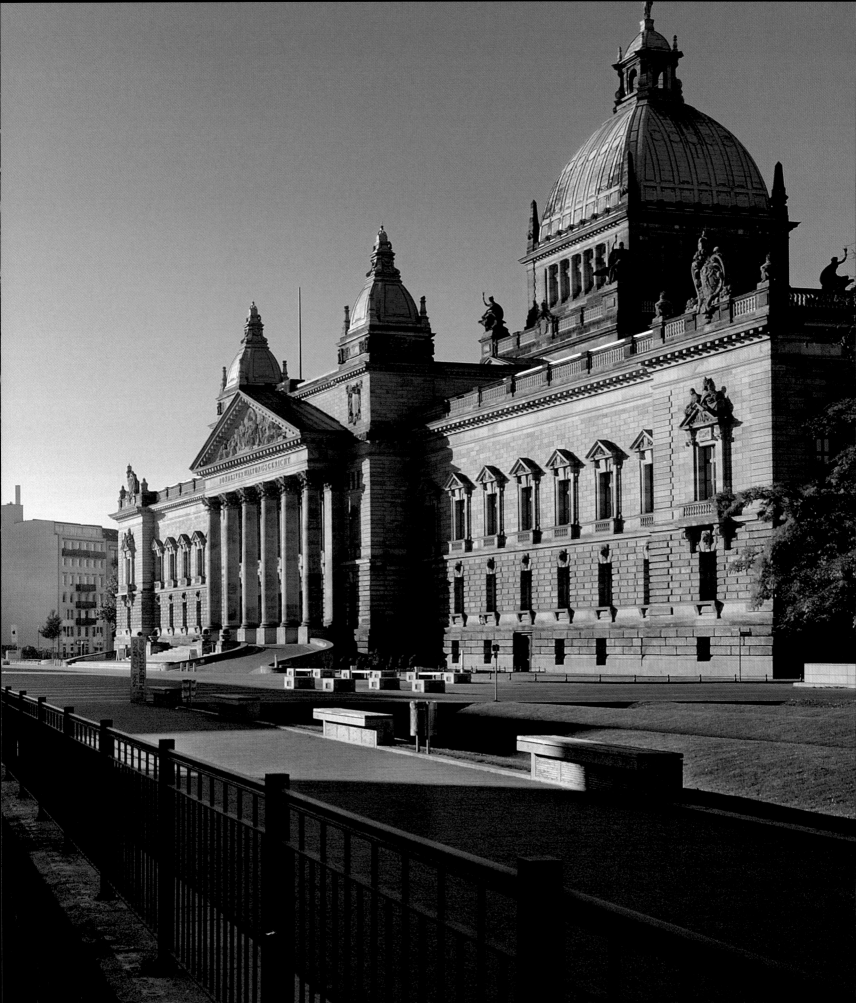

Above:
Truth carries a burning torch high up above her head so that its light can shine out from the top of the court building across the entire empire – or at least that's what the architects hoped to achieve with their symbolism. The German imperial crown adorns the adjacent turret.

Right:
The estate of art patron Fritz von Harck was used to fund this small park with its fountain which offers a cool place of respite in the centre of town.

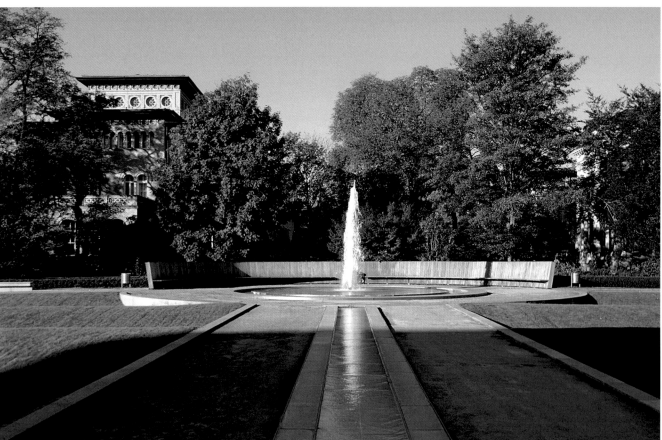

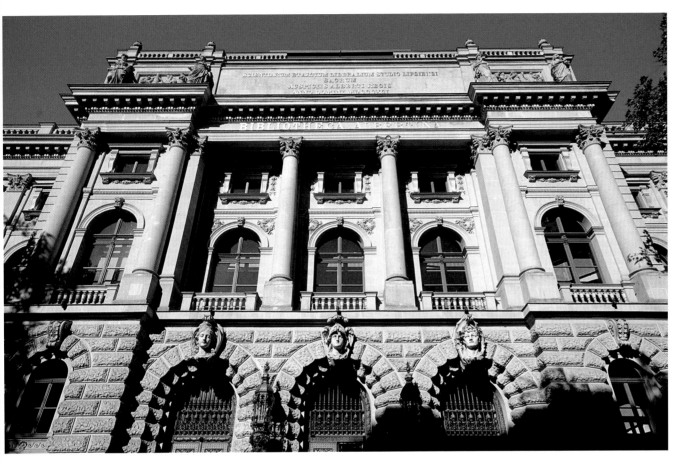

Left:
If libraries are our nation's memories then the Albertina is Saxony's long-term memory, with its archives dating back to the 12th century. Its priceless stock includes the earliest surviving manuscript of the Old Testament. The Latin inscription on the attic reads: "Dedicated to the study of the sciences and the free arts in Leipzig".

Below:
The university library, badly damaged during the war, was restored in the years 1992–2000. Much work was also done on the majestic main staircase leading to the stacks and reading rooms which for decades was out of use.

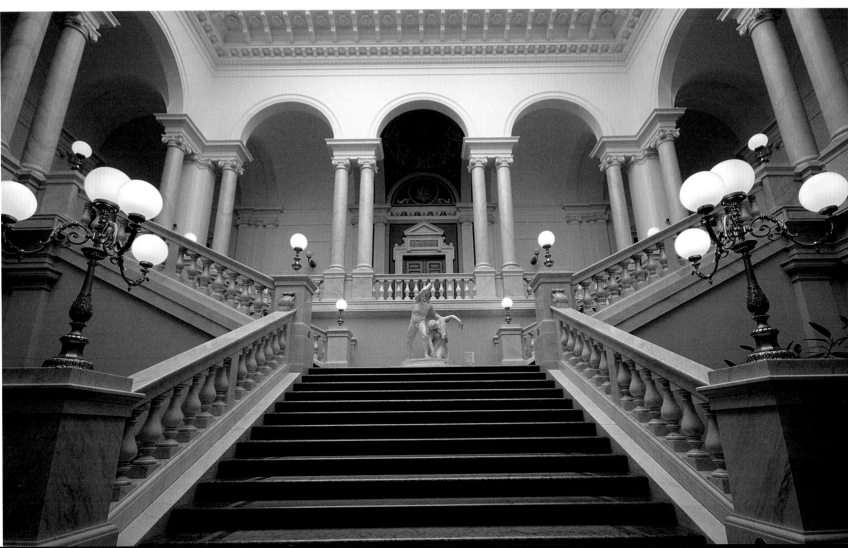

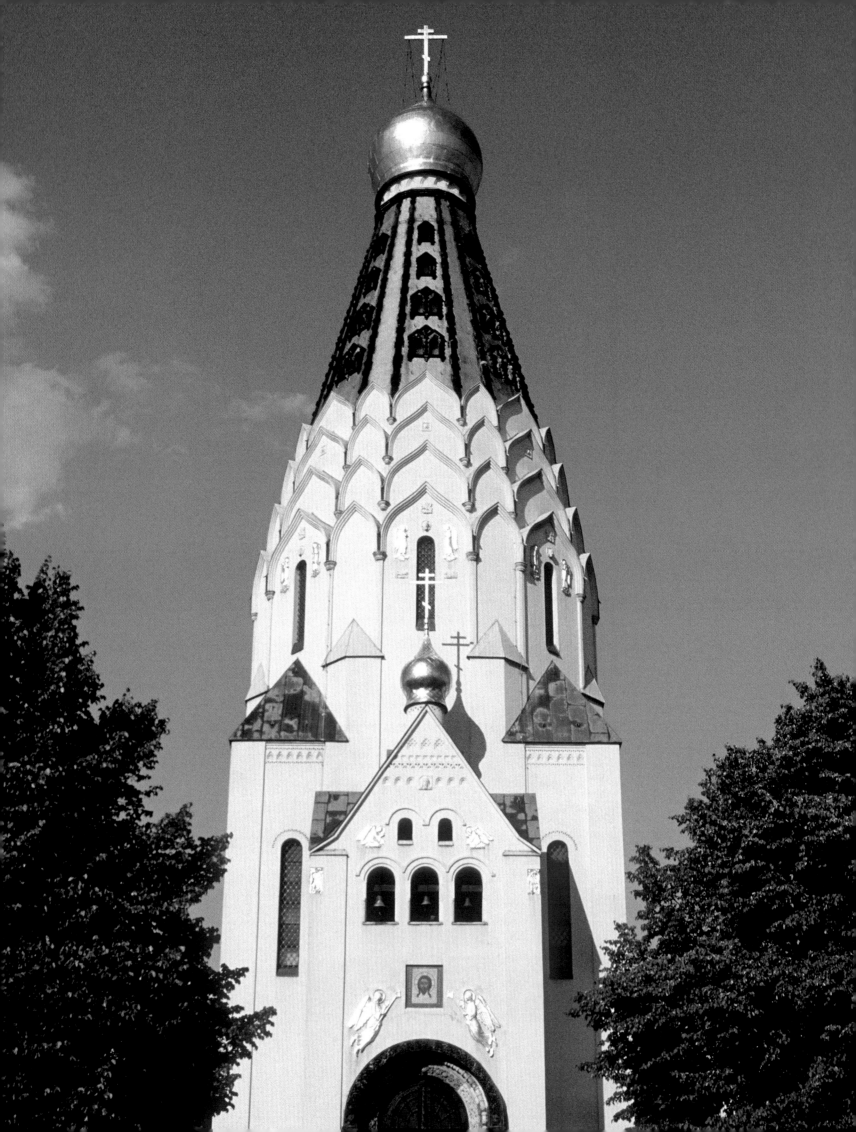

The town villa put up on Beethovenstraße in 1892 is a worthy neighbour of the university library. With it architect Arwed Roßbach has bequeathed to us one of the most splendid specimens of Historicist architecture in Leipzig.

The new Grassi Museum on Johannisplatz is entirely devoted to the Art Deco of the 1920s. Business tycoon Franz Dominic Grassi left the city the hefty sum of 2.327 million gold marks in 1881 which Leipzig used to finance many of its cultural institutions.

Page 104/105:
Even if its precious treasure lies stashed away in the stacks (everything written in German since 1913), the focus of activity at the Deutsche Bibliothek or German Library is on the main reading room. In 2006 the Deutsche Bücherei joined forces with the German National Library, linking it to two other prime bibliophile locations in Frankfurt am Main and Berlin.

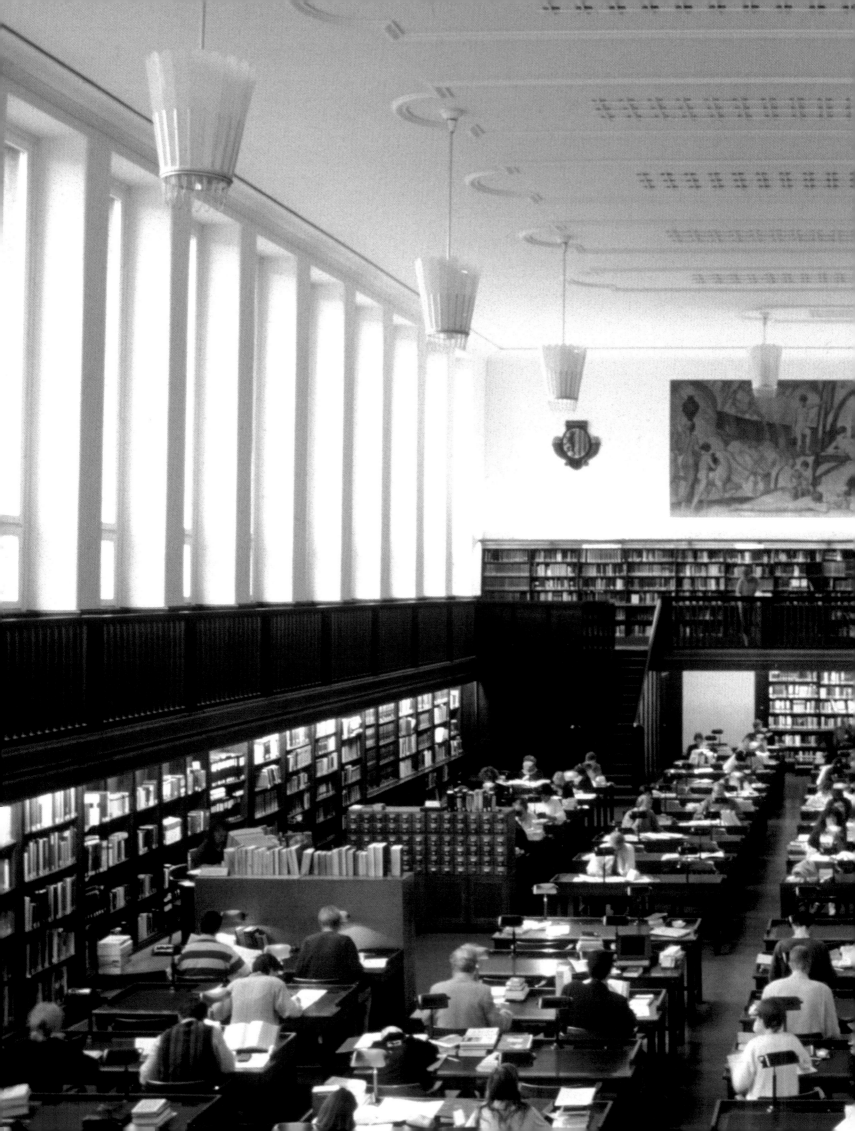

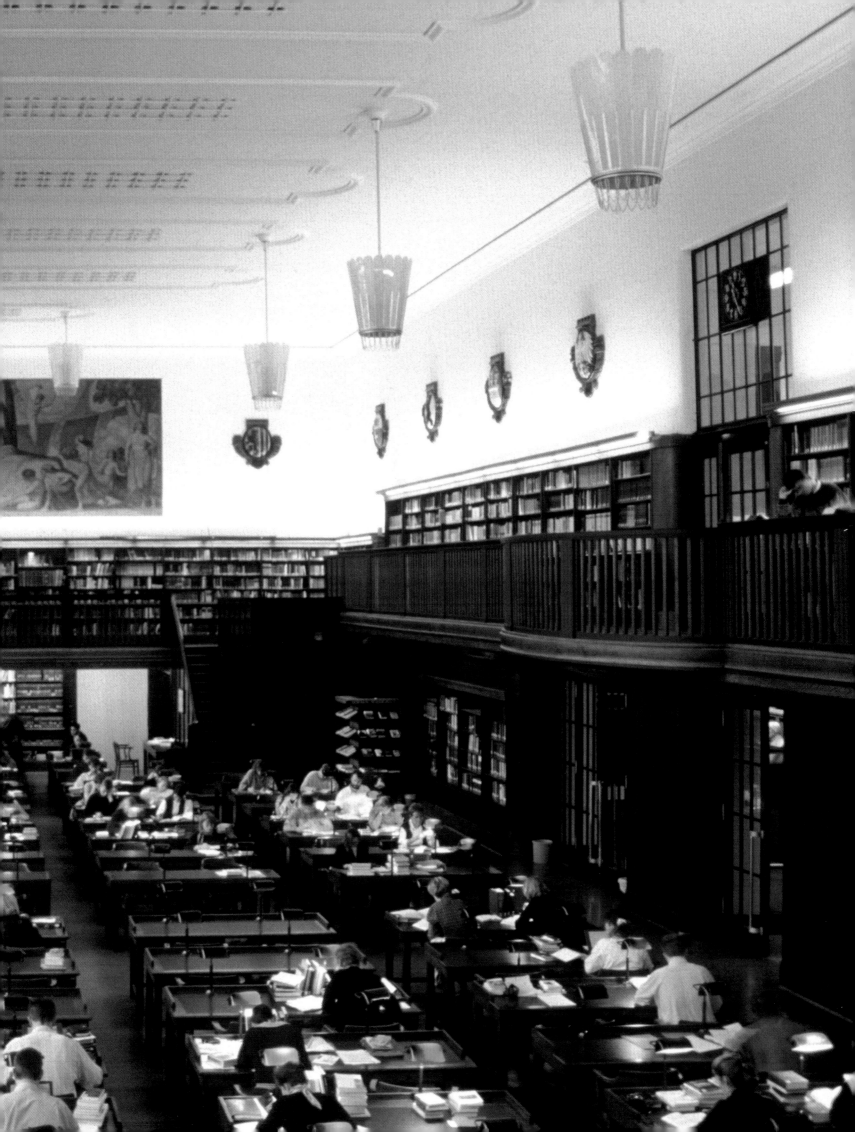

The zoo in Leipzig is a big attraction. Visitors are met by a lion at the main entrance, both the heraldic animal of the city and of the zoo which has been called the "lion factory" due to its success in the breeding of animals in captivity. Creatures great and small not only entertain visitors but also form the basis of scientific research. This particularly applies to primate research

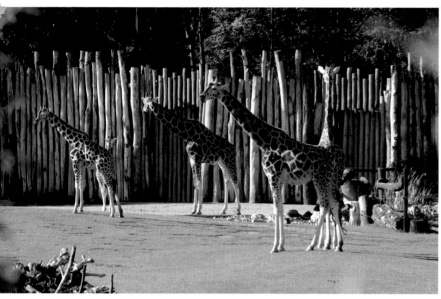

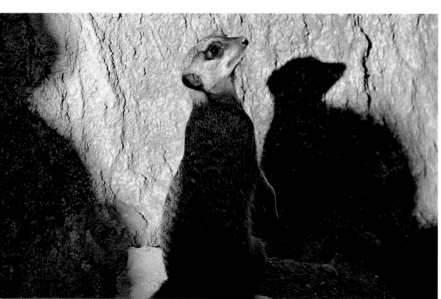

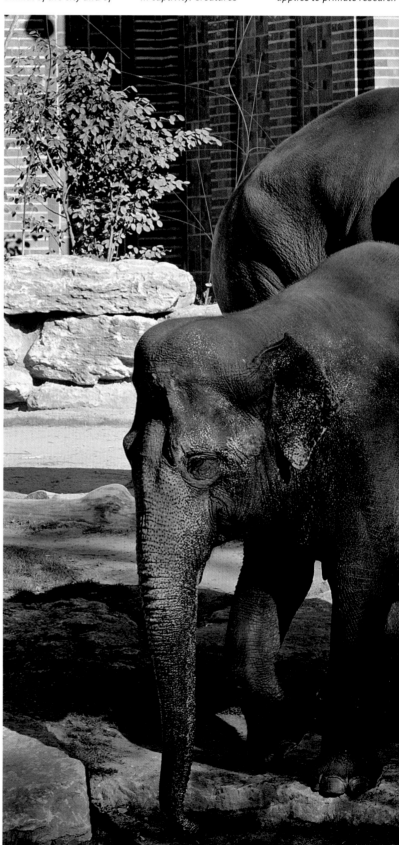

for which optimum
conditions have been
created at the zoo.
Top favourites are the
enormous elephants

and cheeky meerkats,
here happy to pose for
a photo or two.

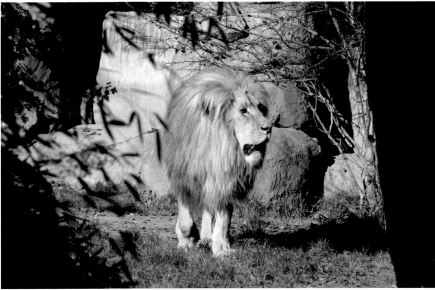

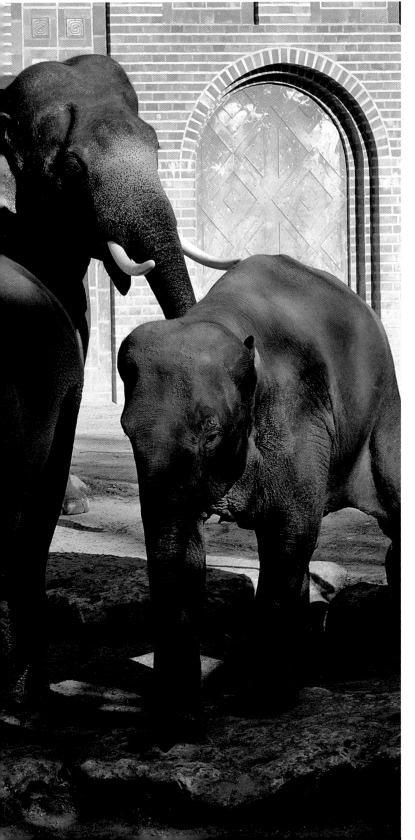

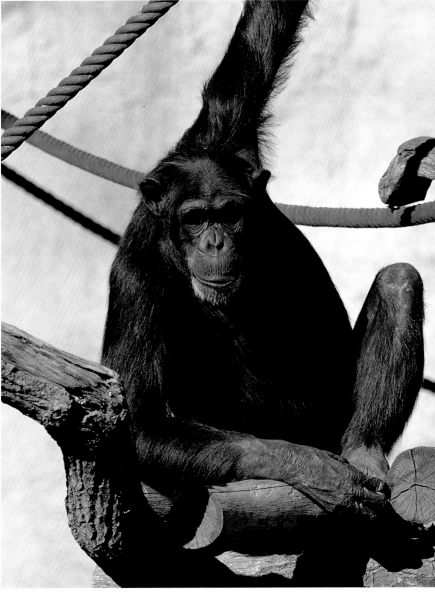

Above:
As the zoo is a modern institute of research the lions are not kept in cages. A habitat has been created for them, known as the Makasi Simba Savannah, which is as close to their natural surroundings as possible.

Right:
Spacious Pongoland is of great interest to both visitors and scientists who here can closely observe the special behaviour of the four species of human ape.

Above:
Leipzig Zoo is currently undergoing massive refurbishment. Landscapes from all continents of the globe are planned with the animals and plants to match. Some of the projects are still on the drawing board; others, such as this path through an Asian bamboo plantation, are already open.

Photos, left:
The zoo complex also includes a congress hall, a multipurpose building erected in c. 1900 with different rooms for various events, a restaurant and a theatre. The hall is currently undergoing restoration.

WOODS AND GARDENS – HORTICULTURAL LEIPZIG

Before the Romantics of the 19th century discovered the forest as a place of spiritual peace and respite, areas of woodland were both a source of danger and of fuel and building materials. The larger the cities grew, the more these natural resources were plundered. With the laying out of the first promenade living trees suddenly became important to the people of Leipzig. Count of Saxony Wackerbarth wrote in 1793: "Oh how still and secluded it is here under the green linden trees! How beneficial to the eyes, how enchanting for the heart! How can I leave this beautiful avenue, unique in its existence!" French writer Madame de Staël also noticed how morally uplifting contact with trees had proved to the Leipziger, remarking on her visit here in 1803: "The honesty of the locals is so great that when an owner of an apple tree fixed a notice to a tree planted on the edge of a public promenade, requesting that none should steal his fruit, no single apple was stolen for ten years. I gazed upon this apple tree with a feeling of deepest respect."

Exotic plants

The gardeners of Leipzig made good use of their international trade connections, cultivating exotic plants from seeds and seedlings brought to them from all over the world, including the black locust or false acacia from North America (*Robinia pseudoacacia*) and the honey locust (*Gleditsia triacanthus*), named after Leipzig botanist Gleditsch. At about this time the green canopy of the forest was discovered as the perfect antithesis to the greyness of the city. Romantic Ludwig Tieck, for example, once proclaimed: "I demanded compensation from Nature for my lost hours and was given it." Leipzig's environs have plenty to offer in the way of recompense. Austrian actor Josef Kainz wrote home in 1876: "Last Sunday we went on our long-promised trip on the river. We left the landing stage at six o'clock on a splendid gondola, stopped in the midst of deep forest through which the Pleiße flows at a tavern and were in Connewitz at the end of our journey in the middle of the Johannapark at eight o'clock. We stayed at a woodland inn until around half past nine in the evening and travelled back through the woods along waterways lit by the moon and the stars. It was a grand and magnificent affair and one would not think to look for so much natural beauty in the vicinity of Leipzig." For decades this beauty was denied the folk of Leipzig, the local rivers and streams polluted from the 1940s onwards by the stinking and poisonous sewage of the brown coal mines. In the past few years things have improved, however, and boats have once again taken to the river. One proprietor has even imported Venetian gondolas from his native Italy. At the end of the 1960s the authorities began flooding the pits near the city, resulting in the sparkling lakes of the Kulkwitzer and Cospudener Seen.

The Rosental, Leipzig's local forest, is part of the Auewald and has its obvious advantages so close to the city – but also a few unpleasant surprises. The waterways which run through it ensure that it always looks green and fresh – but also guarantee that "at the best time of the year in the truly lovely Rosental the mosquitoes do not harbour any kind thoughts". Thus spoke Goethe who in his own words came here to look for some "poetic game". The environmental damage inflicted on the Rosental biotope during the GDR period was so severe, however, that Leipzig poet Georg Maurer was actually glad to see swarms of mosquitoes again going about their evil business.

Animals of a very different kind inhabit the nearby zoological gardens. The park was opened by Ernst Pinkert in 1878 and originally consisted of a pub with a few enclosures and skating ring. It has since become one of the most renowned animal parks in Germany. Once famous for its lion breeding, Leipzig Zoo is now one of the leaders of primate research, working in close collaboration with the Max Planck Institute.

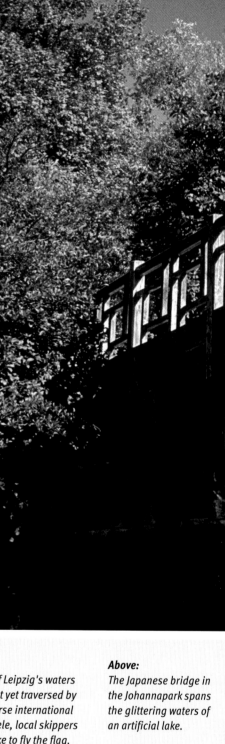

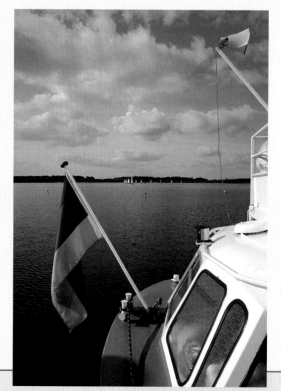

Left:
Even if Leipzig's waters are not yet traversed by a diverse international clientele, local skippers still like to fly the flag.

Above:
The Japanese bridge in the Johannapark spans the glittering waters of an artificial lake.

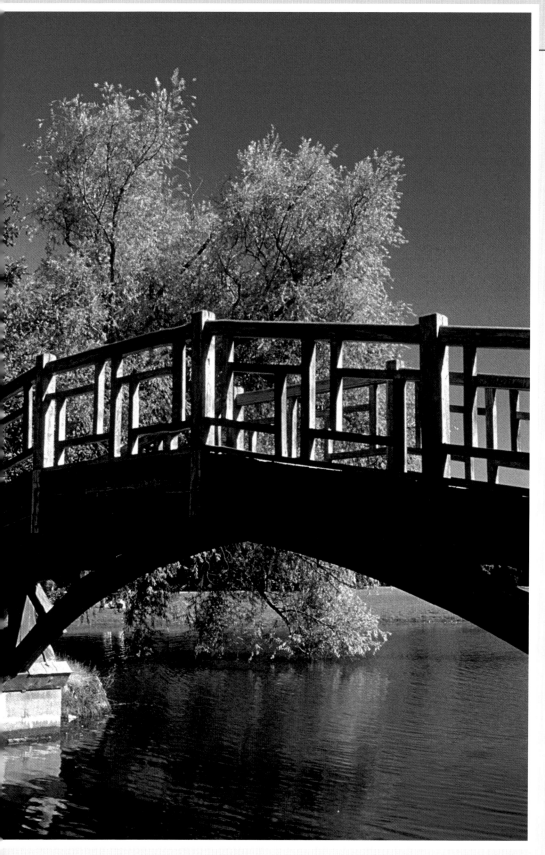

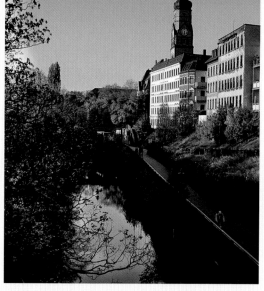

Top right:
The trees of the Auewald are almost amphibian, with some of them firmly 'planted' in water.

Centre right:
A phrase has already been coined for the new lakes springing up on the outskirts of Leipzig: Neuseenland or new lakeland.

Right:
The canal, which was one day supposed to link inland Leipzig up to the oceans of the world, was never finished.

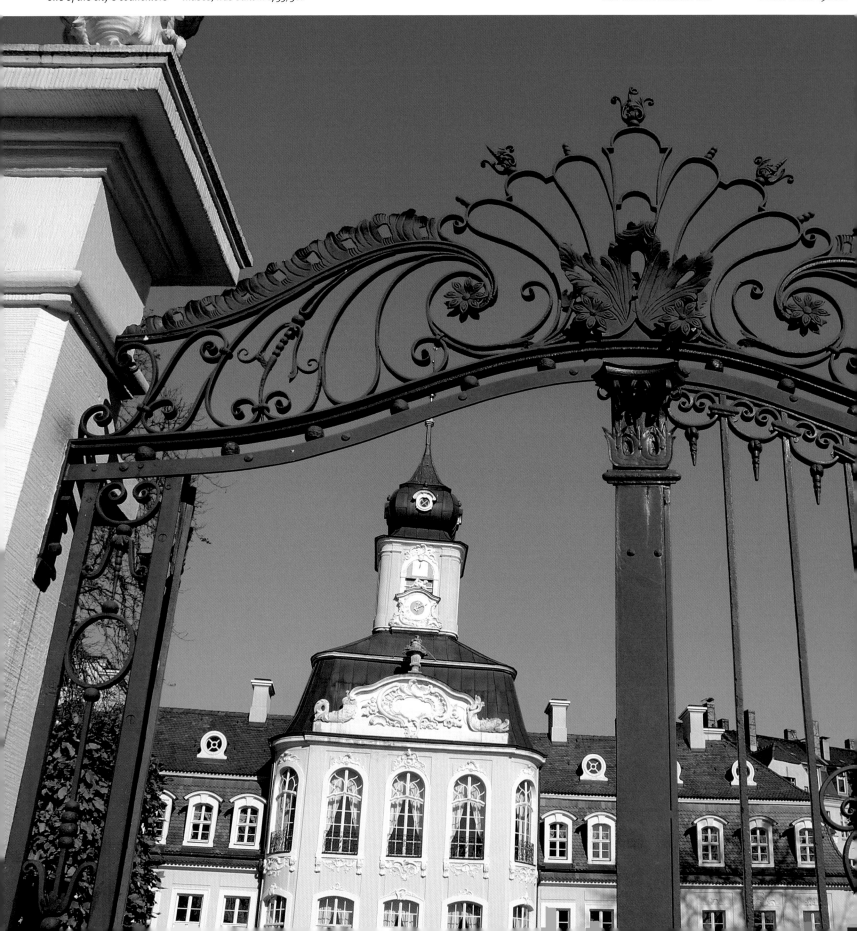

Below:
This small palace in Leipzig-Gohlis was not built for the minor aristocracy but for one of the city's councillors and wealthy merchants. His late baroque villa, which was soon known as the Rosental temple of the Muses, was built in 1755/56.

Top right:
Leipzig's oldest monument was erected in 1780. It shows Crown Prince Friedrich Augustus who in 1806 became the first king of Saxony. It initially stood on Königsplatz (now Leuschnerplatz) but was removed to the Schlösschen in Leipzig-Gohlis in the 1980s.

Centre right:
The ornate cast iron gates of the palace in Gohlis which open out onto Menckestraße are

also baroque. They originally belonged to a building which no longer exists and were installed here in the 1980s.

Bottom right:
Mythical figures play hide and seek in the gardens of the Schlösschen, many of them alluding to the close association between fertility and trade.

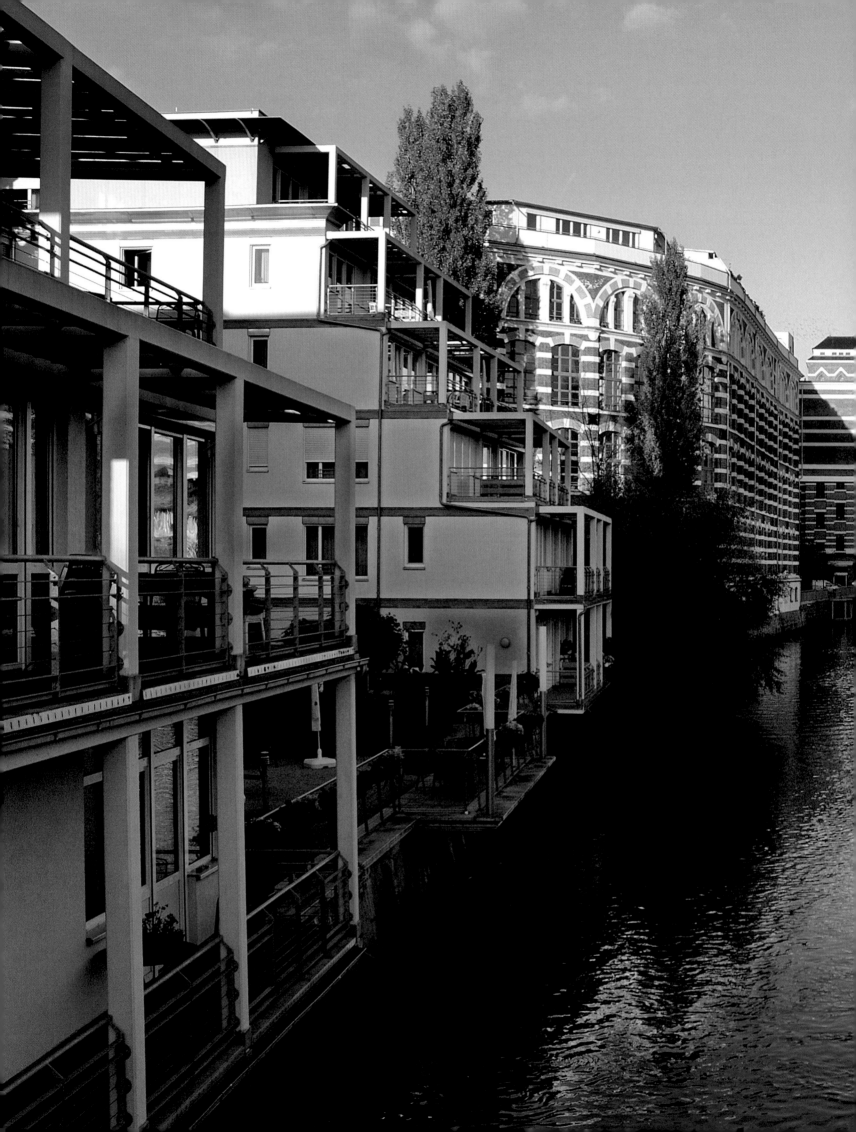

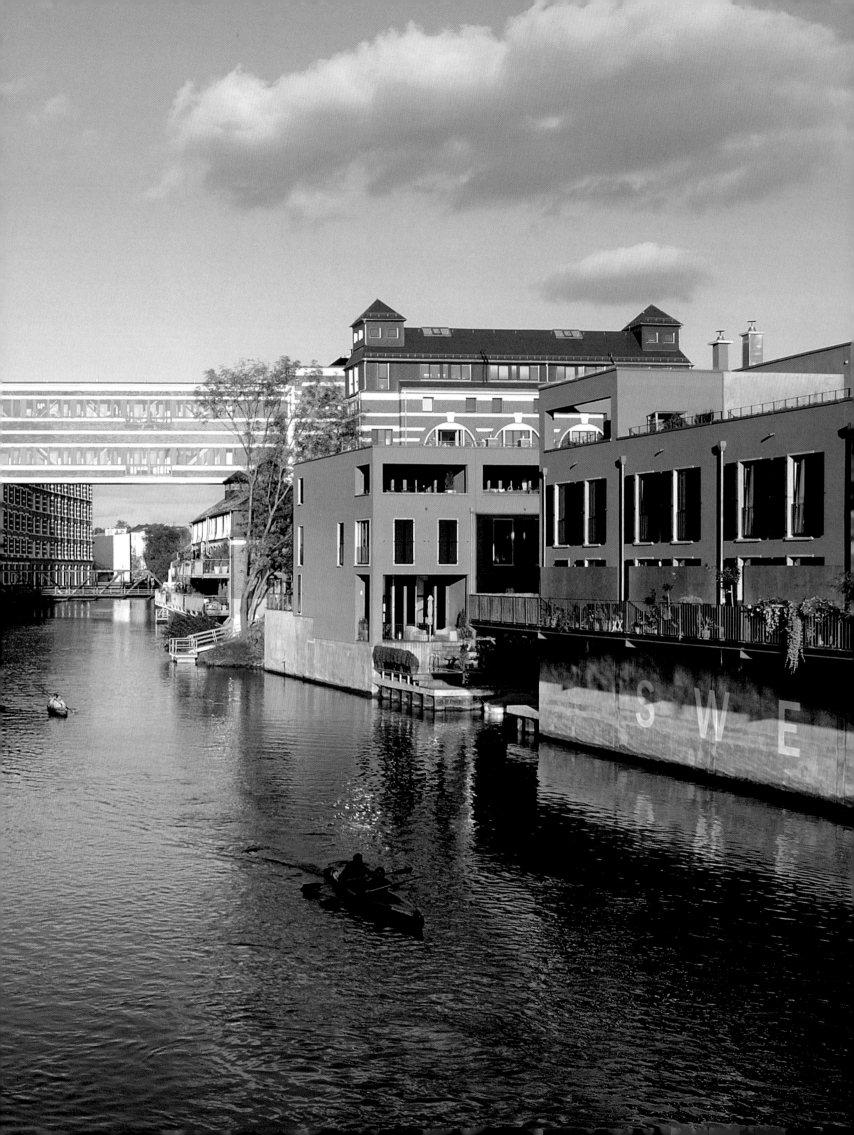

Page 114/115:
In 1990 production stopped at the huge thread works in Plagwitz, built in the 1880s/1890s. The industrial plant has since been turned into galleries, studios, offices, medical centres, pubs, shops and des res lofts, some of which even have their own river access (right of the photo).

Right and right page:
The thread works in Plagwitz, known locally as the Buntgarnwerke, effuse their own distinctive, late 19th-century charm, complete with mock-Byzantine decor.

Right:
The filigree steel grid pattern of the Könneritzbrücke from 1899 sensitively blends in with the surrounding architecture.

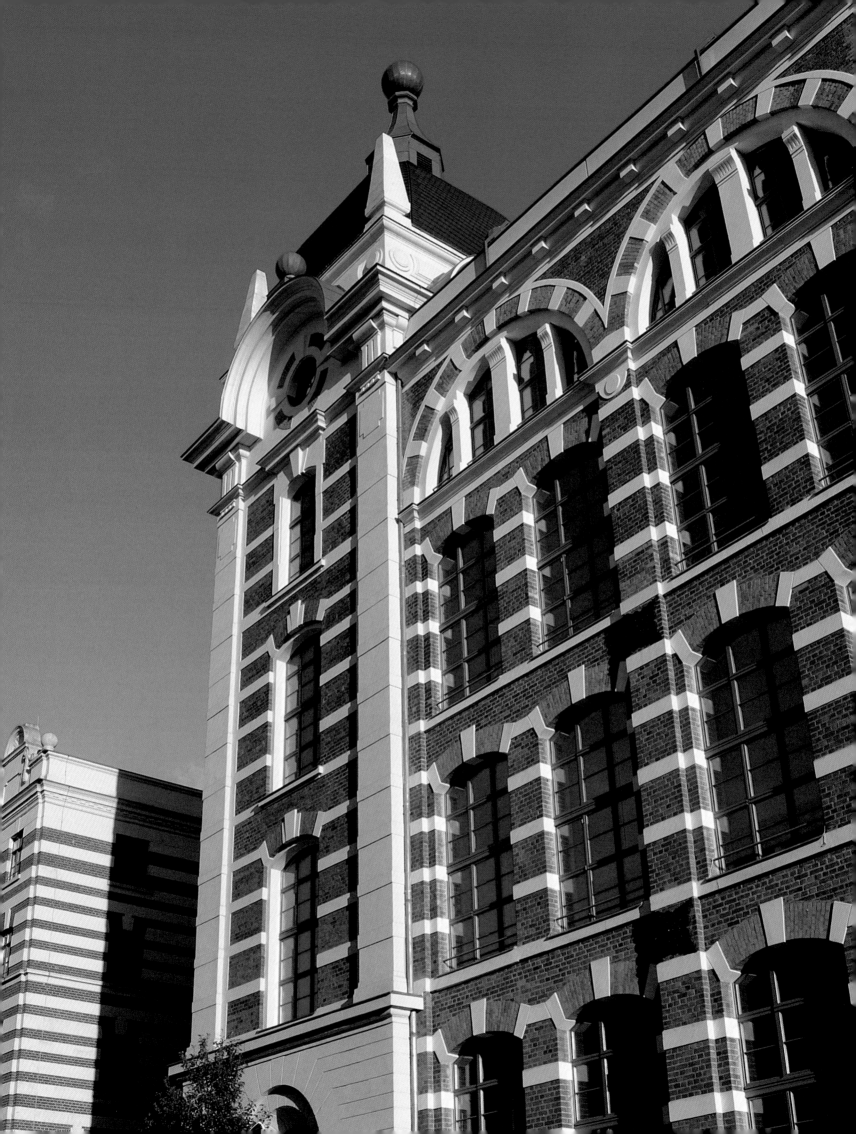

Another example of the successful redeployment of an old industrial site is the former cotton mill in the suburb of Plagwitz. A number of young artists belonging to the New Leipzig School have set up their studios here. Some of the old factory buildings are now conveniently occupied by galleries and shops selling paints and inks, paper and canvas, frames and all sorts of other materials an artist may need. Local actors have also discovered the

rather austere locality, finding it the perfect setting for a production of Schiller's war drama "Wallenstein".

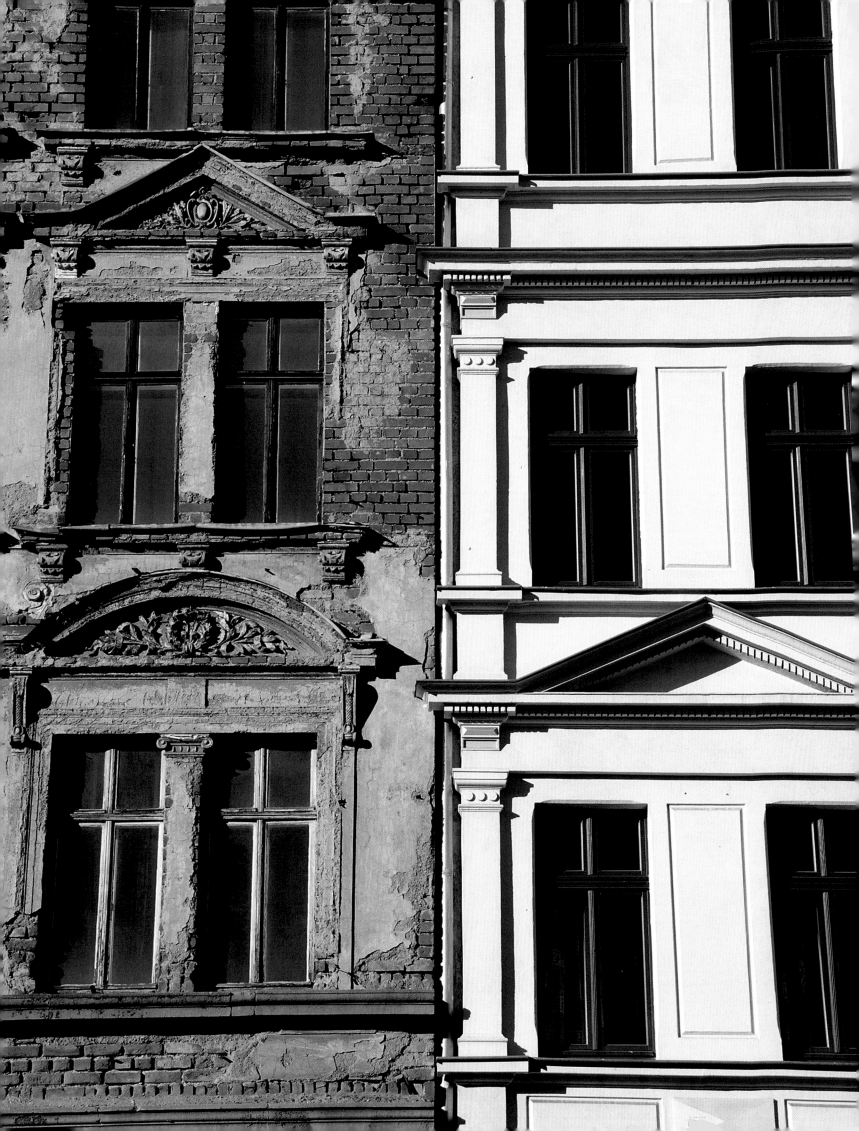

The past has clearly left its mark on the 'industrial village' of Plagwitz, renamed as such during the 19th century. Nowhere else were houses and factories squashed into such a small place. Over time the manufacturing plants have proved more robust than the quarters which housed the workers. The crass contrast between those buildings which have been restored and those which have been left to rot may hold a certain charm for visitors; for those who live here permanently the conditions are far from romantic.

Sanierungsobjekt Nr. 7

Jegliche Beschädigung
führt sofort zur
polizeilichen Strafanzeige!

Spinnereiverwaltung

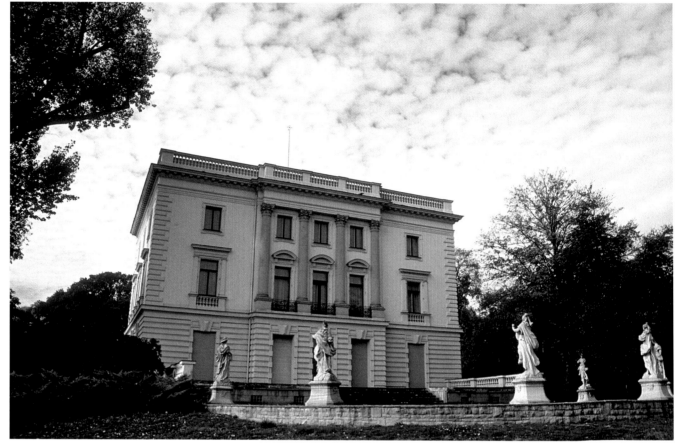

Right and right page:
Even if it doesn't actually fall under the administration of Leipzig the Herfurth'sche Park in Markkleeberg is evocative of the city's gardening tradition with its majestic trees, mixed borders, ponds and streams and mock temples. The villa once belonging to Leipzig's newspaper tycoon is now used for weddings.

Right:
This neo-Classical temple erected in 1830 in Gerhards Garten was later moved to the suburb of Schleußig near Klingerweg.

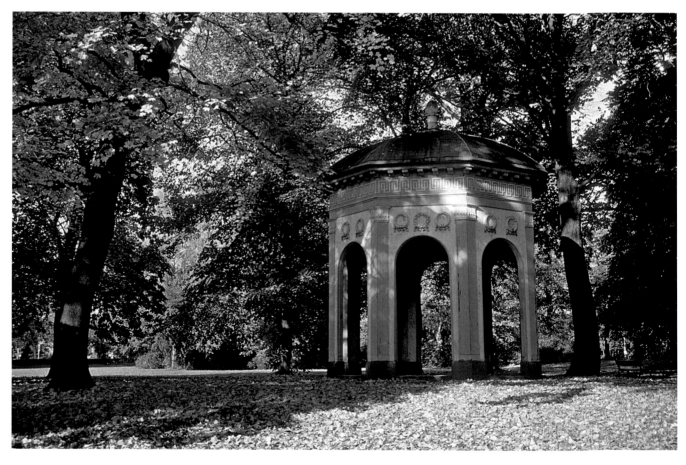

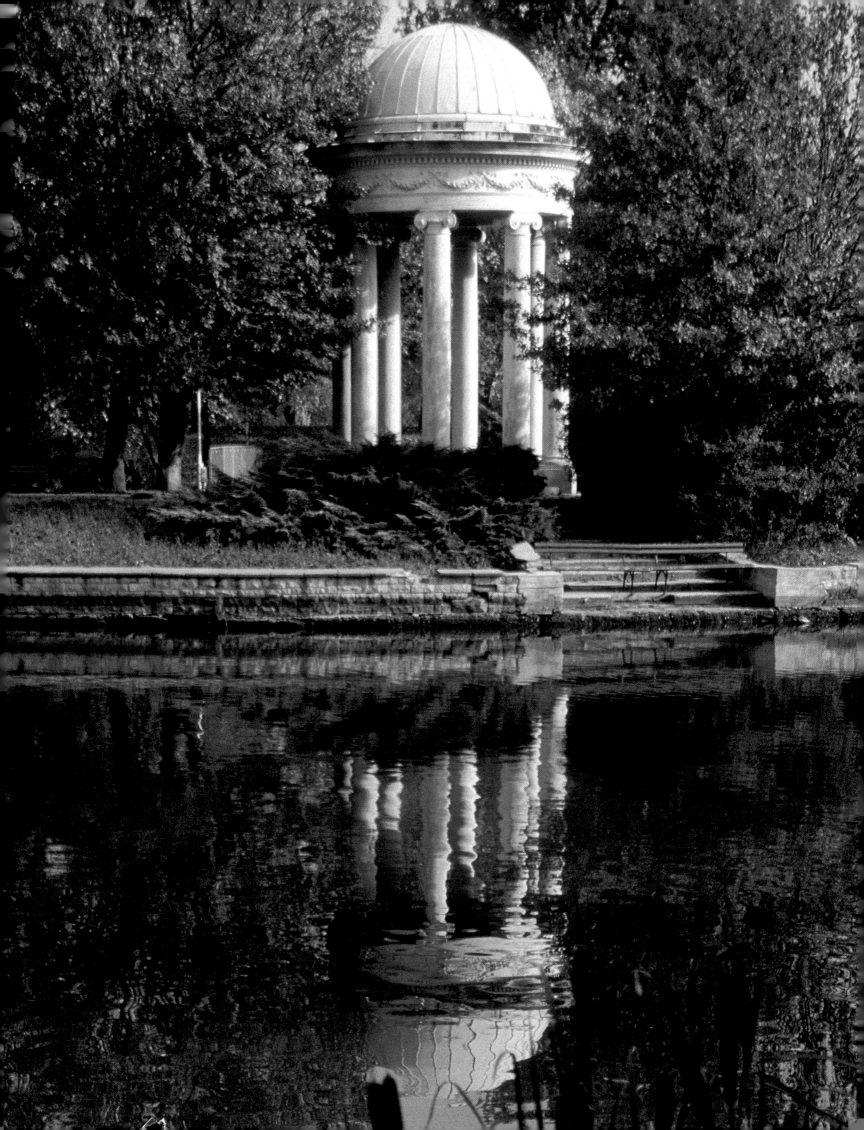

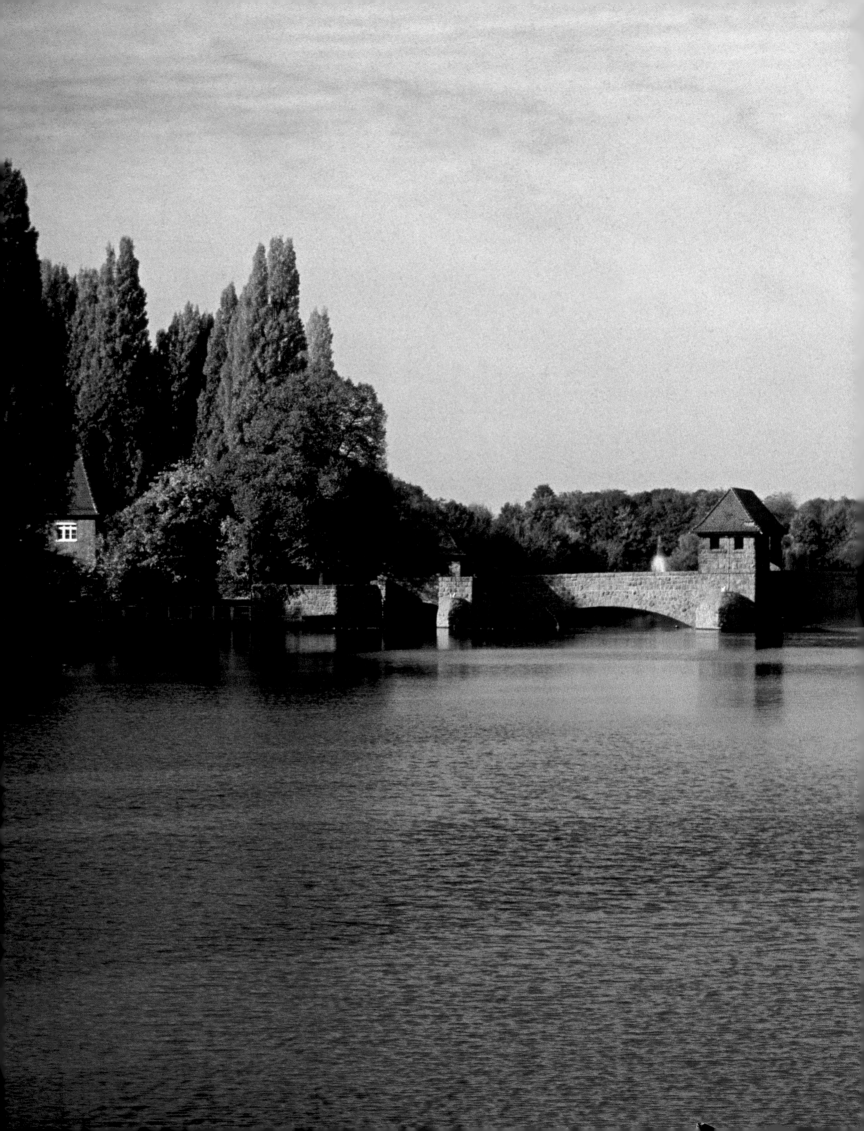

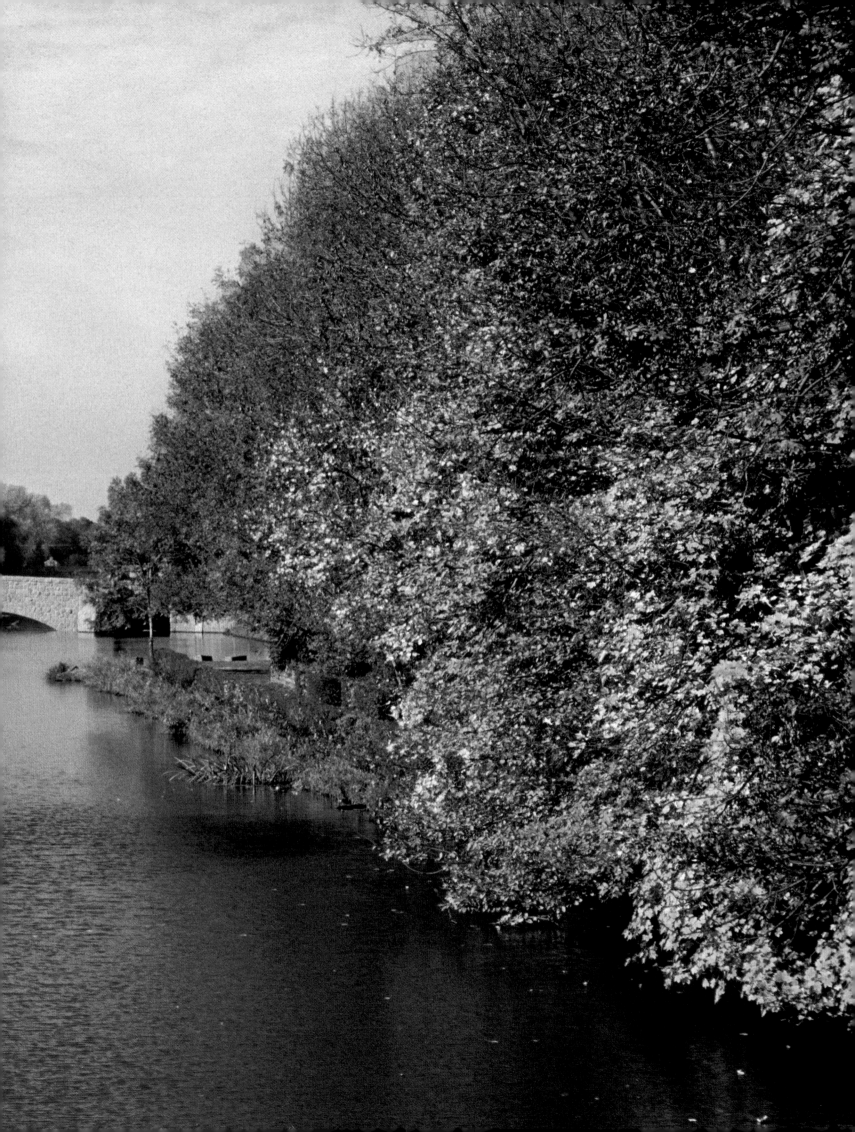

Page 124/125:
Elster, Pleiße and Parthe are the three rivers which meander through Leipzig. In the past they not only regularly flooded the meadows on the edge of town but also the residential areas. The weir in the palm garden, built like a medieval bridge in 1913–17, is one of the successful measures taken to regulate the flow of the water.

Breeder, wholesaler and arts aficionado Maximilian Speck von Sternburg (1776–1856) had his country seat in Lützschena surrounded by an informally landscaped garden which after years of neglect once again revels in its former romantic beauty.

Dominican monks and later the university carefully maintained a hortus medicus, a garden of culinary herbs and medicinal plants. Long lost to the passage of time, in the 1990s the ancient outdoor pharmacy was reconstructed by the university.

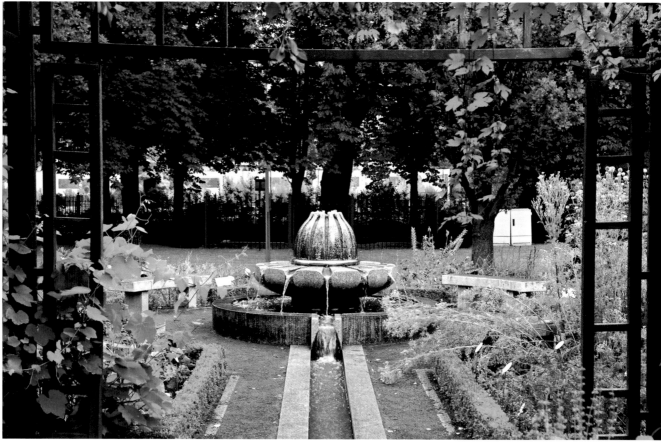

Right page:
Historic Schloss Machern, half an hour's drive from Leipzig, once belonged to the imperial counts of Lindenau who had the grounds informally landscaped during the 18th century. During Goethe's day and age they also ran Auerbachs Hof in Leipzig.

On April 12, 1996, a new age dawned for the Leipzig Trade Fair which has proved just as much a milestone as the transition from the sale of goods in booths to the display of samples in permanent, elegant halls in 1895. Up until then Leipzig had not had a fair-ground where a functional, contained and aesthetically pleasing space could be adapted to suit various forms of presentation. The central glass hall is linked up to the exhibition halls and the congress centre by a system of tunnels.

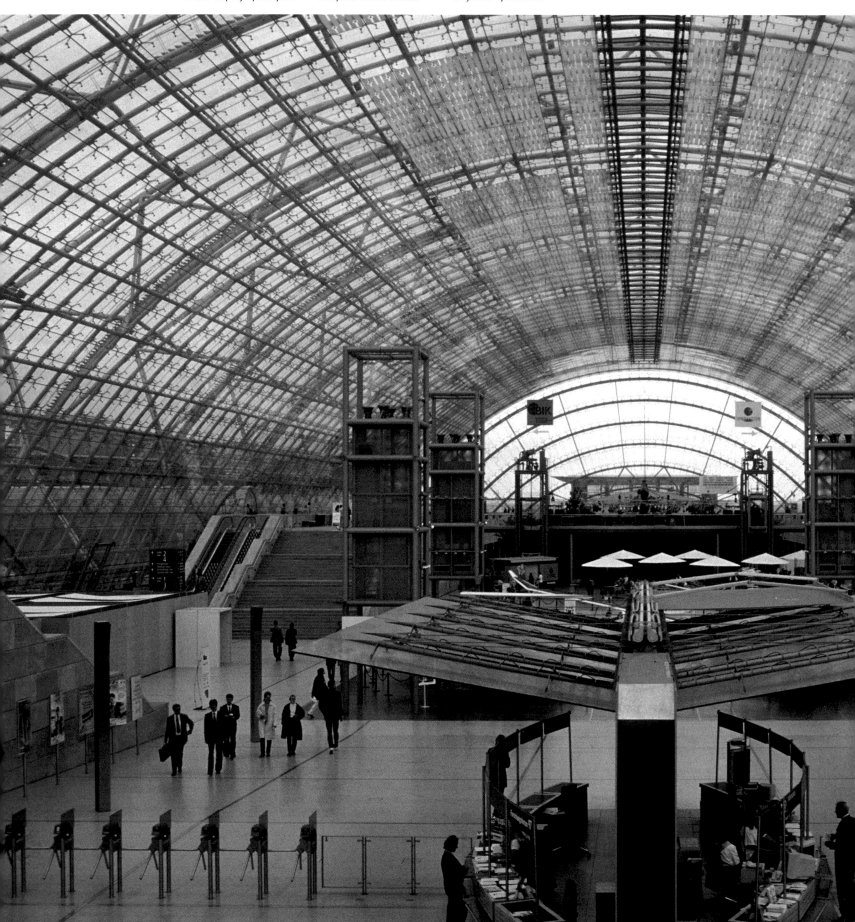

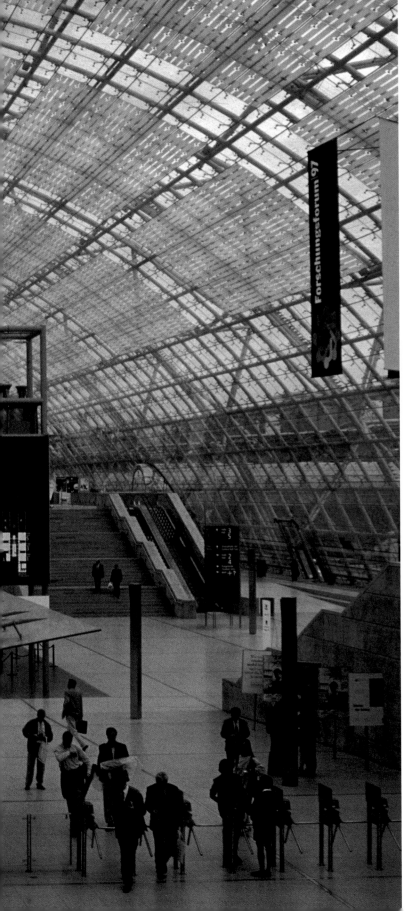

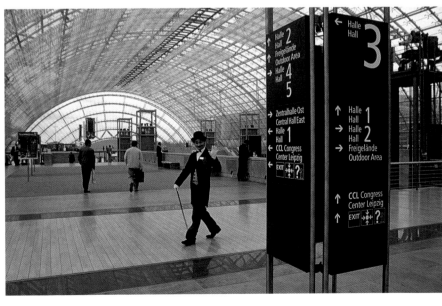

Since the intensification of brown coal mining in the 1930s about 100 villages, suburbs, hamlets and farms in the Leipzig area have been bulldozed. In some cases church bells or even entire churches could be saved, their memory kept alive for future generations. The lost village of Cospuden, however, lives on in name alone – in the lake which now floods the place where people once lived and worked. The creation of new lakes such as these is a great boon to the flat, low Leipzig Basin, otherwise devoid of sizeable stretches of water. These new lidos offer little comfort to the villagers who have lost their homes, however.

Page 132/133:
Cospudener See is a fine place to watch the sun go down on a warm summer's evening.

INDEX

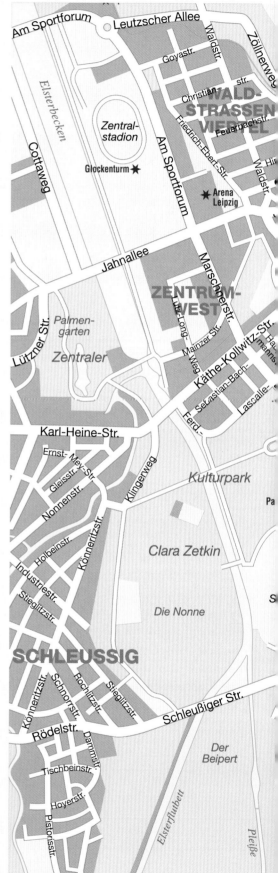

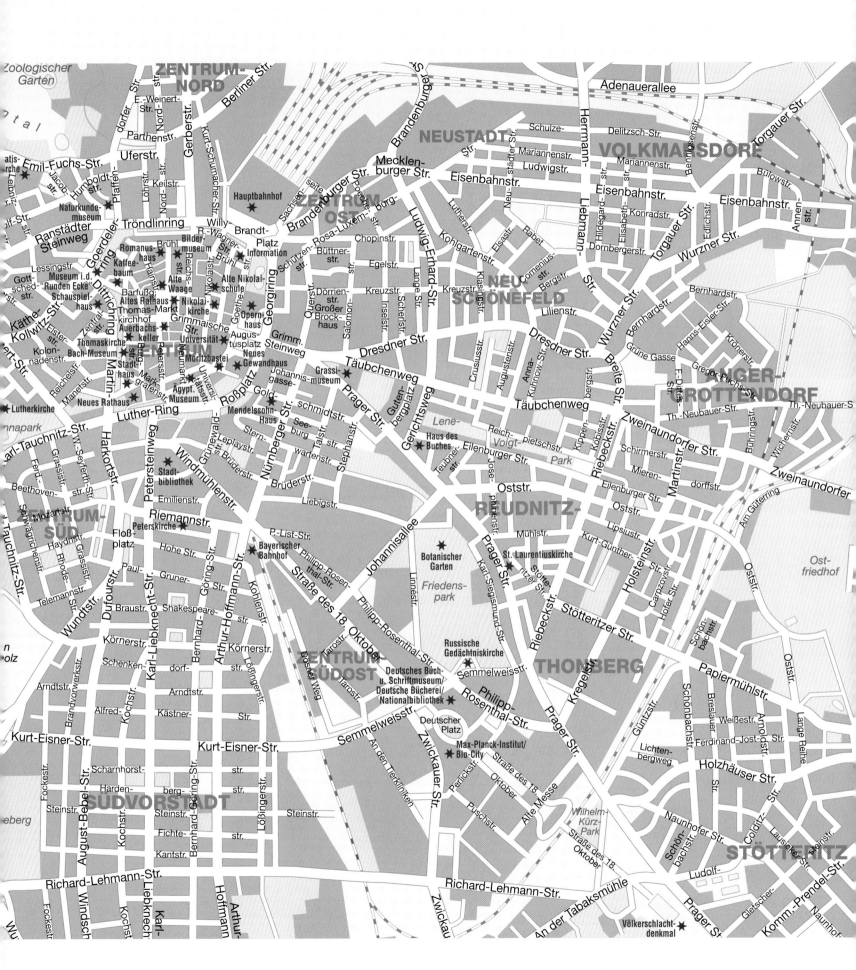

View of Leipzig at night, with the Neues Rathaus in the foreground.

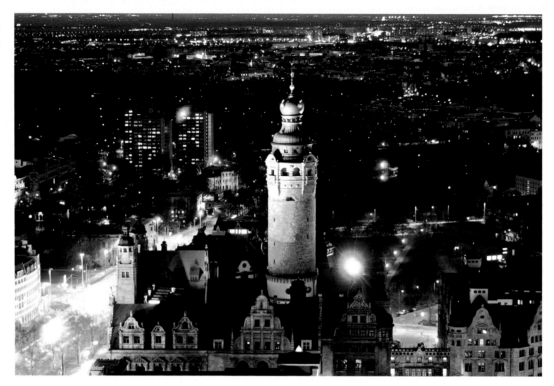

Credits

Design
hoyerdesign grafik gmbh, Freiburg
www.hoyerdesign.de

Map
Fischer Kartografie, Aichach

Translation
Ruth Chitty, Stromberg
www.rapid-com.de

Printed in Germany
Repro by Artilitho, Lavis-Trento, Italy
Printed/Bound by Offizin Andersen Nexö, Leipzig
© 2008 Verlagshaus Würzburg GmbH & Co. KG
© Photos: Tina and Horst Herzig
© Text: Bernd Weinkauf

ISBN: 978-3-8003-1918-3

Details of our programme can be found at
www.verlagshaus.com